THE GUIDE TO FANTASY ART

Techniques

Edited by
MARTYN DEAN

Text by
CHRIS EVANS

based on interviews between the artists and Martyn Dean

ARCO PUBLISHING, INC.
New York

Published 1984 by Arco Publishing, Inc.
215 Park Avenue South, New York, NY 10003

A PAPER TIGER BOOK
©Copyright 1984 Dragon's World Limited

©Copyright text Chris Evans 1984

Library of Congress Cataloging in Publication Data

Main entry under title:

The Guide to Fantasy Art Techniques.

 1. Fantasy in art. 2. Art — Technique. I. Dean, Martyn.
N8217.F28C6 1984 702'.8 84-16730
ISBN 0-668-06233-9

Produced and edited by Martyn Dean

Printed in Germany

Ian Miller

Preface

Some guidebooks are written like instruction manuals, giving point-by-point information and advice. They can have their merits, but frequently their tone is drily factual and they talk in generalaties or give lists of Dos and Don'ts. Often they fail to convey anything of the excitement and even mystery involved in practising a creative art. They have no personality.

Yet any artistic field is defined and shaped by its top practitioners. These people tend to be very distinct individuals who have their own philosophies and working methods of which their art is the end product. They may share common aims and approaches to their work but they also tend to be ground-breakers who defy tradition and convention, thus pushing back the boundaries of what is possible. In this book the artists themselves are given the chance to speak.

The Guide To Fantasy Art was conceived to present a behind-the-scenes view of the creative processes in fantasy art — in answer to the question: Where Did You Get The Idea? Established professionals were interviewed about their backgrounds and the ways in which they approach their craft. The questions were also designed to provide information and tips which might be useful to the beginner.

Fantasy art is imaginative art, depicting worlds which lie beyond the grey reality of our everyday lives. It embraces everything from mystic landscapes inhabited by quixotic creatures to the complex technologies of the distant future. It may be scientifically plausible or completely fanciful. Yet it will always contain images designed to startle us by their sheer novelty or strangeness.

Where do the ideas come from? And how are they brought to life by the artist? These two fundamental questions, and many related ones, were put to eight artists who are at the forefront of their chosen fields. The aim was to achieve as broad a conspectus as possible, and the contributors range from traditional oil-painters to airbrush specialists, from commercial designers to model-makers. The result is a series of very different yet complementary insights into the lives and minds of innovative visualizers. It adds up to a comprehensive single-volume portrait of the fantasy artist and the sources of inspiration which shape him.

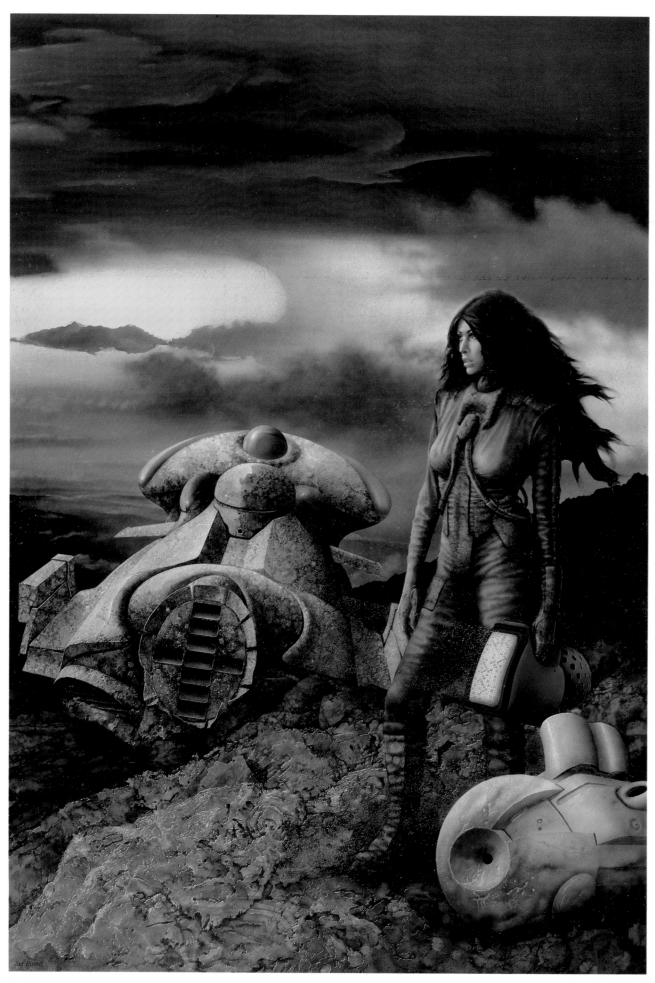

Jim Burns

Contents

Introduction

Any art with mass appeal expresses something of the spirit of the times; it reflects people's hopes, fears and enthusiasms. Fantasy art has never been more popular than it is today, nor have there ever been as many artists at work in the field. We live in a period which is fascinated by the romance of worlds more colourful and bizarre than our own.

Trends in mass culture can best be seen by looking at what fascinates the young. In the 1980s traditional heroes such as the gunslinger or the tough cop have been displaced by the starship pilot and the barbarian warrior. Many of the most popular films such as *Star Wars* and *ET* are out-and-out fantasy vehicles, while the success of video — and role-playing games — which also largely deal in exotic locales — shows what a strong-hold the realms of the fantastic have on children and adults alike. We now accept the strange as commonplace; but we are always yearning for more.

Most of the artists in this book grew up in the 1950s, and it's no coincidence that this period corresponds with the start of the Space Age. Sputnik was launched in 1957, and suddenly it seemed as if the future had arrived. Soon human beings were flying into space and we were no longer confined to our own planet. From being a remote and unreachable place, the Solar System and the Galaxy beyond now began to seem like a great back yard which we could begin to explore. Space could be colonized — and what better vehicle to take us to the ends of the Universe than the power of the human imagination?

The 1960s saw an acceleration of the Space Race and a growing affluence in Western nations. Popular culture was never more accessible: books, magazines and comics proliferated, and cinemas were at everyone's disposal. Consumer products flooded onto the market, and ordinary people began to acquire the fruits of a burgeoning technology: cars, washing machines, vacuum cleaners, record players, bri-nylon shirts. But above all, they acquired televisions.

Television added a new dimension to most people's lives, making the impact of world events more immediate and allowing people glimpses of societies and cultures quite different from their own. Despite the many criticisms which have been levelled against it, television willy-nilly encouraged a broadening of perspective. It made people think of what might be — either in reality or through the expression of an

inner vision showing potentials or alternatives to what is.

This is the context in which many of today's top fantasy artists spent their formative years; it was then that they acquired the visual and thematic vocabulary which they would eventually transform into their own illustrative language. Even the most original imagination never springs out of thin air; it is a product of its particular age, of primary experiences which include the impact of other artists' work on the developing mind. Thus, in the profiles which follow, attention is paid to the artists' early years and the important influences on them.

It's perhaps a truism to say that the artist must have talent to achieve success in any field. But talent is the expression of a potential rather than an achievement in itself. For potential to be fulfilled, it must be harnessed to a temperament which will cultivate it; it has to be developed and refined through practice. An artist may be self-taught or have had a formal education in the basics of his craft, but without practice he will not acquire the technical resources to make the most of his abilities. With this in mind, the biographical information on each artist also covers the crucial years of apprenticeship during which the raw talent was perfected to a professional standard.

Wherever possible, an attempt has been made to place the artist in his present-day context by describing his studio and the mediums which he uses. Over the past twenty years or so a wide range of new materials and instruments have been introduced which the modern artist can make use of — airbrushes, acrylic paints, plastics, adhesives, fibre-tipped pens, and so on. In some cases these new materials have led to new art-forms, and in every case they affect the kind of art which is produced. Details are therefore given of paints and paintbrushes commonly used, and information is also provided on airbrush propellents, drying times, methods of masking and underpainting, and specialist processes such as vacuum forming and brass etching. There is also advice on specific techniques applicable to certain kinds of art which have been acquired through experience and which may spare the beginner many frustrations.

Today's freelance artist often has to produce work quickly for clients. To make the best use of their time, many artists work on several paintings at once, but a given piece of art can take anything from a few days to several months to complete. There are artists who work

normal office hours, while others are less organized with their time. Of the eight represented here, all have done work for commercial clients, yet they differ in the proportion of time they allot to commissioned work. Some prefer to concentrate on private work for exhibitions or illustrated books, while others need the impetus of deadline pressures in order to be able to produce at all.

Leisure activities can also be important to the artist. The work itself may demand complete concentration, and often the most fertile period for ideas is when the artist is relaxing. In order to give as rounded a portrait as possible, it was important that the recreational side of the artist's life was not neglected.

So much for background, lifestyle and working method. All these are important, for they shape and define a talent. But it's the actual imagery in the art itself which expresses the talent. How does an idea emerge in the first place? And how is it brought into two- or three-dimensional life by the artist? These are elusive questions, since creativity is characterized by instinct and spontaneity, which do not readily lend themselves to logical analysis. But what an artist *feels* at the moment of creation can be just as revealing as what he *thinks* about it after the fact.

The eight participants in this book all make a living from their art, but the interviews are less concerned with the fact that they are commercial illustrators than that they are people who have specifically chosen fantasy art as a means of expression. What are the compulsions and fascinations underlying such a choice? In today's world conventional religion plays a less influential role in most people's lives than at earlier times, and it might be argued that the widespread popularity of fantasy art lies in the fact that it offers us new versions of the iconography which has traditionally been the province of religion. Its stock-in-trade is emotive imagery, and this may range from cosmic visions of a glorious future to nightmarish worlds haunted by demons and ghouls; it is filled with images of transendence and damnation, reflecting our deepest hopes and fears. If we regard the basic religious impulse as a yearning for better or different things, then fantasy artists could be seen as prophets in more than just the strict sense of visionaries.

It's always difficult to assess the intrinsic merits of any art without the benefit of hindsight. Popular art is seldom that art which is

critically respectable, yet much of what is now accepted as fine art was originally produced on commercial commissions, be it Da Vinci painting frescos in churches or oil painters with wealthy patrons doing portraits of favoured sons, daughters and wives. There has long been a debate on the distinction between illustrators and artists, some seeing the commercial motivation as indicative of an inferior class of work, others seeing no real difference between the two. The eight contributors here range from those who would prefer to work exclusively for themselves to those who entirely reject the idea of being a hobbyist. Yet all of them express their individuality through their work and regard it as having some worth. But exactly how much value do they place on the originals, and how important is it to them that they survive? These are significant questions which help highlight the seriousness and purpose which underlies an artists's output.

We live in an age which is visually orientated for many people, film, television and two-dimensional illustration has superseded print as a source of information and stimulus. Yet it is a sobering thought that many of the ways in which we currently record facts or visual impressions are relatively transient. Books were once printed on rag-paper which would last centuries, whereas today cheap paperbacks often fall apart after a few years, while electronically stored information could be erased in instants by the electromagnetic pulse from a nuclear warhead. The Old Masters painted with natural materials on canvas or wood or masonry, and their paintings have survived six or seven hundred years. But modern artists paint on boards or papers whose life expectancy may only be decades. Even transparencies are made of gelatin, which will gradually deteriorate. We still assume that our age will be the most documented to date, but ironically modern methods of storing the masses of data which we produce may prove to be the most ephemeral of all.

This is a gloomy prospect, perhaps, but it may serve to emphasize the fact that this book and the artists it contains are about today. And about the immediate future as well. An imaginative heritage can survive the destruction of the physical object, and today's fantasy artists may be creating the visual imagery which will influence the upcoming generation not only of artists but of architects, designers and manufacturers — the people who will shape the world in which we and our descendants will live.

Jim Burns

Jim Burns is in the process of building a studio in his back garden, but at the moment he works in his living room. "I see other artists surrounded by all the paraphernalia that a real illustrator should have, and I feel a bit of a phoney sitting there in the living room with my kids all over me while I'm painting. But I love the racket of family life."

Most of the illustrations that Burns produces are for book covers, and he's rare in that he always reads the books which he illustrates. "What I see as attractive in an illustration is its narrative quality. I like the picture itself to tell part of the story. I try to be totally honest to the tale or the section of the tale illustrated. I get a lot of satisfaction from the recognition of the parameters imposed by the story. That's a discipline which in the end makes the job more interesting from my point of view. The same is true of cover-briefs. I don't like them because so often the brief is some ostentatious requirement on the part of the client. But I try to turn the brief back to some semblance of honesty with regard to the tale. It makes life awkward but it's a challenge — nothing becomes an indulgence."

In the last ten years, Burns has produced around three hundred illustrations, and his art reveals a versatility which is comparatively rare among painters. He enjoys hardware, but he's equally at home with pictures that have a more human dimension. Self-critical and constantly striving to improve, he claims that his figure-work is poor — an observation which reflects more on his own high standards than on the paintings themselves.

A Welshman, Burns was born in 1948 and served in the RAF for eighteen months after leaving school at 18. "I've drawn all my life and I loved painting, but in my childhood all I ever wanted to do was to fly aeroplanes." He was accepted for pilot training, but eventually failed to qualify because of "a lack of sufficient flying aptitude. I'm not sorry now, anyway". He left the RAF in 1968 and did a year's foundation course at Newport College of Art in South Wales before going on to St Martin's School of Art in London. On leaving college in 1972, he was taken on by the Young Artists agency in London and has been with them ever since. "It's a very happy relationship. Some people are very outspoken against agencies, but Young Artists have always been extraordinarily useful to me. They really earn their commission."

One of his first jobs was to produce pencil drawings of the Space Shuttle for 'Design' magazine. "That was the last thing I ever did in pencil as a finished job. At college I used nothing but coloured pencils, and for early jobs I used ordinary graphite pencils and a little bit of watercolour. It was made obvious to me that these were not the things for book jackets, so I bought myself some gouache paints. At art school nobody said anything about technique, and I learned more in my first year after leaving than in my whole time there."

Burns spent a couple of years doing covers for historical romances, which he hated but found beneficial in that it forced him to concentrate on portraying figures. Later, when he began to do more and more of the science fiction painting which he prefers,

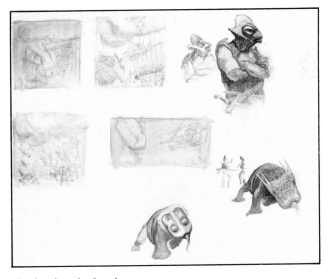

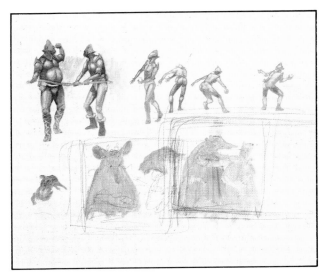

Sketches for a book jacket

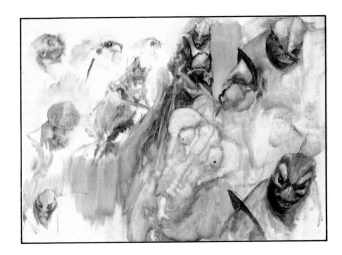

he found that figures kept creeping into them. "People seem to like the human element in my pictures. I have a feeling that it's to do with them being seduced by figures that aren't drawn *quite* correctly and therefore become unsettling. In perhaps an almost intangible sense, I also like the notion that my pictures are a bit like windows — the figures in them catch you looking at them."

In addition to book-cover art, Burns has also produced an illustrated book, *Planet Story* with the SF writer Harry Harrison, and various designs for the computer wizard Clive Sinclair which include software packaging, a computer/telephone/flatscreen T.V. console and a three-wheeled electric car. The last of these turned out to be very similar to wind-tunnel models which had already been made.

In 1980 Burns spent ten weeks in Los Angeles, doing designs for the film *Blade Runner.* "They wanted quick-fire ideas on paper. I was at the time working in oil paint almost exclusively, and to do quick-fire things in oils is impossible. Nonetheless, it was a terrific experience, and when I got back from Los Angeles it made me move from oils to acrylics because you can work more speedily and spontaneously in that medium."

He paints on hardboard masonite, sizing the board with a white acrylic primer. "I use an American acrylic gesso which I find more suitable than its British equivalents. It gives me a good white base on which to work. The paints then go straight on top of that." He uses an airbrush as well as a paintbrush,

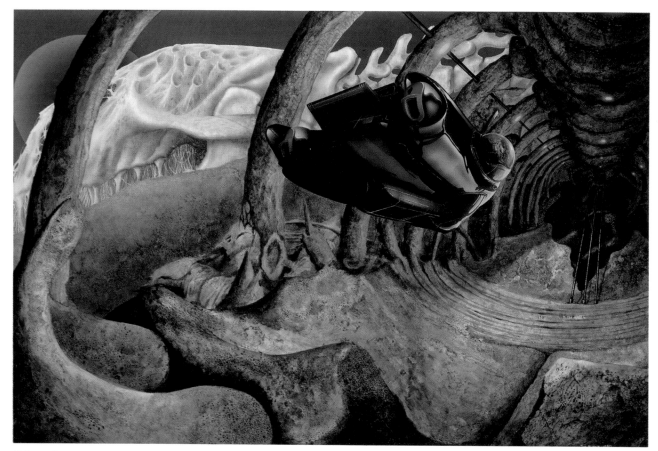

Behemoth

spraying with acrylics which he mixes with water. "I've never encountered any problems. I use a latex masking fluid — gallons of the stuff. I paint it on to the surface I want to mask. With acrylics it doesn't stick to the surface. It's terrific stuff — just made for the job.

"I put on layer after layer of thin colour through the airbrush. I end up creating colours that are unavailable in tube form — there's a transparent sequence of colours coming through. As with Maxfield Parrish's blue — which he built-up with glazes. I find that with the thinned-down acrylics through the airbrush you start to get the same kind of vibrancy." The final stage is to give the painting a coat of acrylic varnish.

How does a picture begin life? "The idea always comes from the writer. Everything I read always unfolds visually like a film in my mind. I suppose I mentally freeze an image and translate it onto a board in paint. The idea arrives externally and I act as a sort of vector." He starts with lots of small sketches, usually in pencil or fibre-tip pen. "The initial scribbles are indecipherable to anyone but myself. They're just scribbles of balances of weights and shapes and masses — where I want a figure, roughly how I want the figure to look."

Burns likes to work the composition out quite thoroughly. "When I was at art college I was always told that composition was never my strongpoint. It's something I've worked on more and more over the years, and now people tell me that my composition is actually quite strong."

Does he work out a colour scheme? "Not really. Everything I send off in rough form to a client is always accompanied by sheets and sheets of scribbled nonsense on the colours I have in mind. Invariably by the time I do the painting those colours alter." He doesn't supply colour roughs unless they're asked for, but his sketches are so detailed that sometimes people want to buy them.

He paints seven days a week — day and night — and finds that he has to discipline himself to *stop* working. "I've actually got more interested in each painting over the last couple of years. I've found that I'm discovering new techniques and abilities that I get terribly involved in — I don't want to put the paintbrush down at all. I've worked on two paintings at once, but it's a problem of logistics. When the studio's set up, hopefully I'll have three of four paintings on the go at once."

Sketch for a book jacket

Sketch for a book jacket

Sketch for a book jacket

Mortal Gods

Because he's a perfectionist, Burns is always tempted to keep working on a painting, trying to get it exactly right. But deadline requirements eventually force him to call a halt. "I take all the time I've got on a job to complete it. I'd love to spend a year on a painting, but economically it's obviously unjustified." But while time-factors can be frustrating they can also be beneficial. "I'm conscious that at some point on a painting — usually about three-quarters of the way through — if I had any sense I would say, 'That's it — finished'. To my eye, some of the paintings I do can look overworked because I've gone beyond the point at which it would have been sensible to stop."

At the moment Burns is content to concentrate on commissioned work, though he would like to do the occasional illustration for himself if time permitted. "All the elements I like painting come into all the illustrations I paint, but it would be nice once in a while to put them together in a way that didn't relate to a book jacket format. I've got a big painting on the go at home of a unicorn — it's just about the only painting I've ever done for myself. I started it about four years ago and it's not finished yet. I go back to it

every so often and add a daub of paint to it. Perhaps the best idea would be to have a few long-term projects of my own on the go."

For reference Burns collects books, magazines and books on art nouveau jewellery. "I go through colour supplements, magazines, any printed matter, looking for anything with potential, and I tear pages out. I've got files subdivided into such categories as 'Male Reference', 'Female Reference', 'Costume', 'Aviation', (further subdivided into historical periods), The Sea, Architecture etc". Other categories include *Motor Cars* and *Exotic Hardware*, the latter containing anything that looks suitably technological. "For example, I had a picture of a Merlin engine from a Spitfire. It suddenly occurred to me that it might be a good idea to turn that into a spaceship in an illustration. (see 'Tower of Glass', Robert Silverberg/Bantam Books.) Usually there's a photograph or two involved in it. I'll look at the way metal reflects the light in a photograph, and I'm trying all the time to recreate it in paint. If it means layer after layer of different colours, that's the way I'll do it."

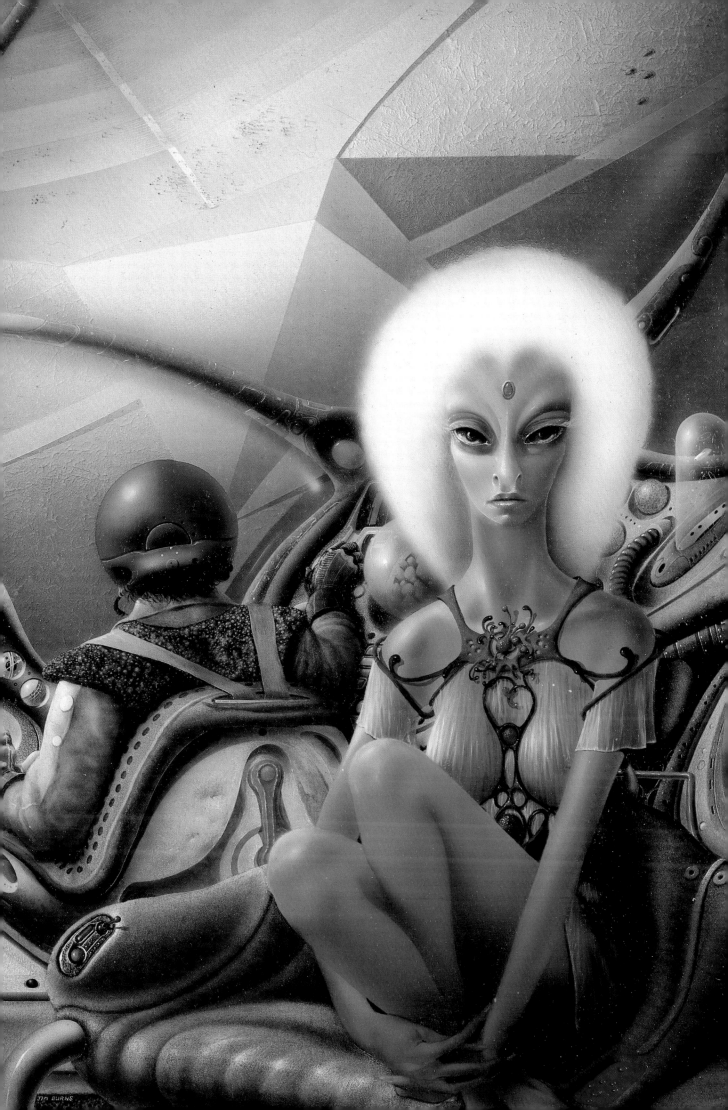

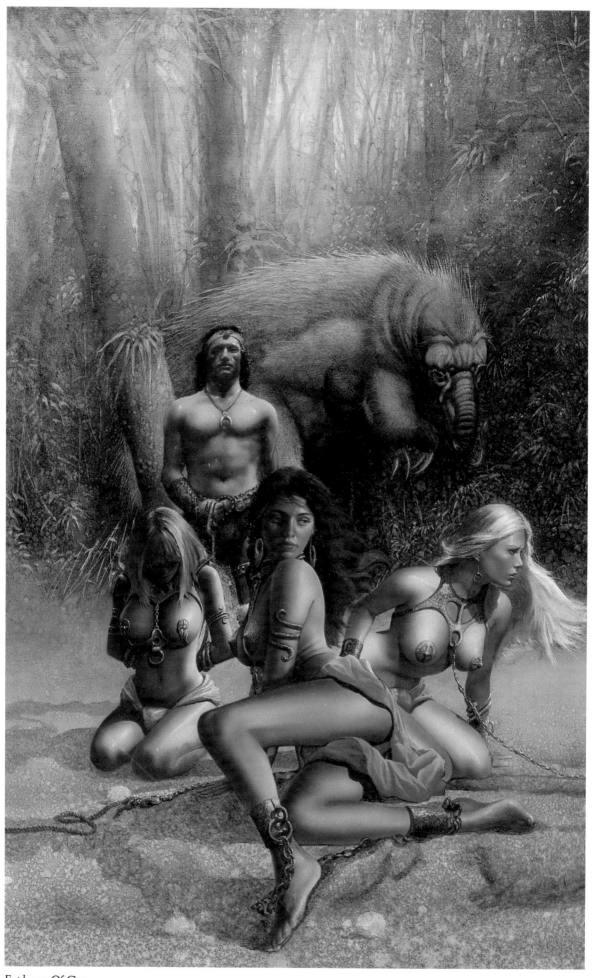

Explorers Of Gor

Rough Sketches

Burns enjoys depicting futuristic vehicles, and they are one of the distinctive features of his art. He tends to eschew the angular, monolithic craft favoured by many of his contemporaries for a more rounded, ornate appearance. His spaceships often look as if they've been carved out of rock or moulded from glassy stone, and they may be ornamented with metal curlicues and wings like the fins of fish. He likes to use the term "baroque technology" when thinking of ways in which he wants to render hardware.

"I was looking at a pilot's helmet which was fitted with a sort of aiming device that comes down across the eye — real *Star Wars* stuff. I dislike the function, but it looked so baroque and so wonderful as an object. There are all sorts of strange, unknown rationales behind creating these odd shapes and encrusting an object with details. I like to assume that the implied esoteric way of thinking will exist in the future even to veer off into exotic avenues so far unsuspected."

So what effect is he trying to create? "Visual richness, I think. No more than that. It's an entertainment in its own right, and there's no intellectual rationale behind it. I want my pictures to have a general appeal to ordinary people — I can't stand artistic posturing. But I like the hardware to look as if it

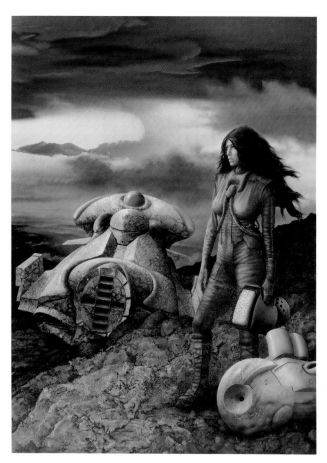

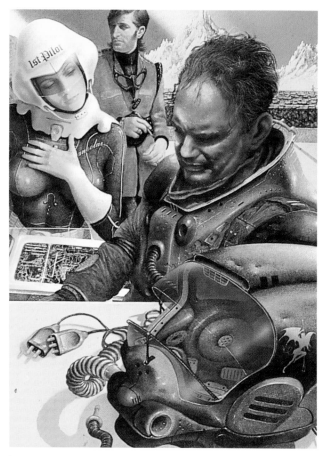

Brother To Demons

Spaceport from 'Planet Story'

may have a function. Even my limited knowledge of aeroplanes affects the design. If you sit in the cockpit of an aeroplane you see all the detail most people aren't aware of. It's the suggestion of those bits that I want to plaster all over my things. I like to make the hardware look as if there's some human thinking behind it. Or, even better, alien thinking."

Burns cites a Cordwainer Smith book which described an alien spaceship as looking like two fried eggs joined together. Until then, he was used to the traditional idea of spaceships as pointed cylinders with wings at the end, but now he's drawn by the challenge of depicting alien technologies.

Among his influences, the "Dan Dare" artists Frank Bellamy and Frank Hampson from the *Eagle* comic are the most important. "If ever I aspired to what I'm doing now, it was from 'Dan Dare'. I don't remember the actual stories — I just loved those images. The kind of kick I got out of them is the kind of kick I'd like

to think young people are getting out of looking at my things. Wowie-zowie sort of stuff. The Gee Whiz Syndrome, as it's known." He also mentions illustrators such as Howard Pyle, N. C. Wyeth, Maxfield Parrish, Arthur Rackham and natural history artists of the 18th and 19th centuries. Art with a narrative quality has always appealed to him. "Also the sheer unadulterated *technique* of some of them which is available to so few these days."

Does he have a concern for the intrinsic worth of his own paintings? "The finish of the actual painting has always been important to me. Book jackets are reduced down from the originals, but if you look at one of my paintings you'll find that the detail is there but more so. I love the actual object that is the painting. I'm not over concerned if they mess it up on the book jacket." Even so, he has little sentimental attachment to the originals and will sell them if the price is right, keeping a transparency for himself.

Majipoor Chronicals

20

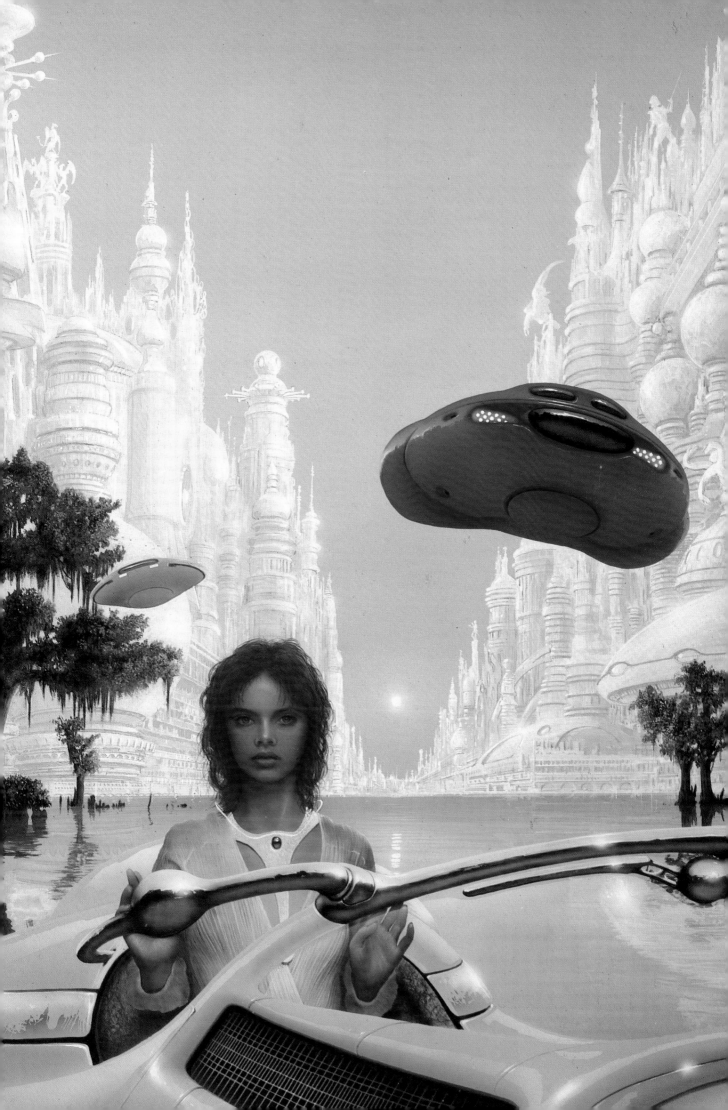

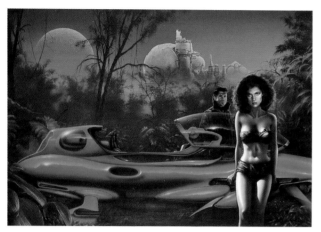

The Lovers

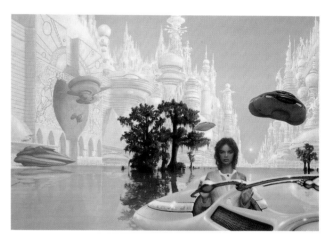

Majipoor Chronicals

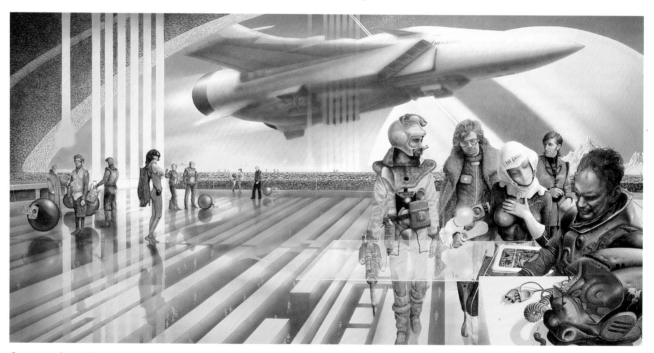

Spaceport from 'Planet Story'

Conscientious and ever-determined to improve his craft, Jim Burns possesses both the discipline and the talent which should assure him continuing success. What are his current ambitions? "I'd like to work bigger and get more detail in. I'd like to make the paintings richer. I particularly want to try to convey ar-tifacts which are the products of truly alien minds and different sets of perceptions. And to suggest materials other than wood or metal or plastic — somehow! Ships of onyx of opalscent vessels ploughing bizarre oceans of liquid metal under skies tended by twin or triple suns — all that sort of stuff!"

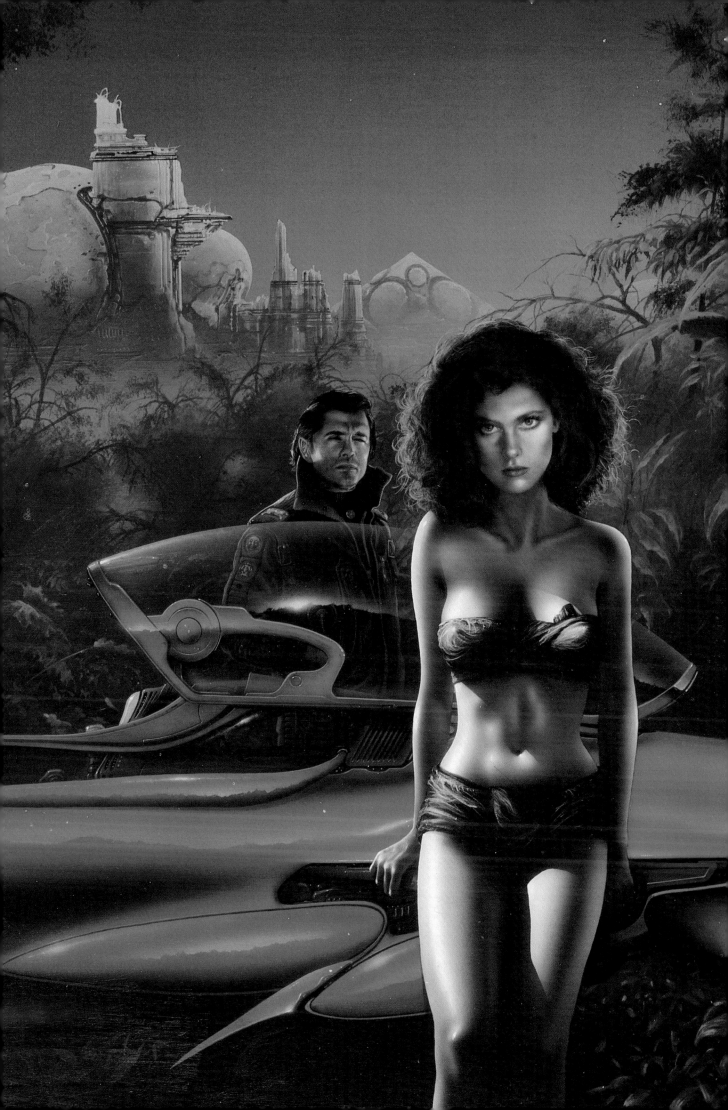

Ian Miller

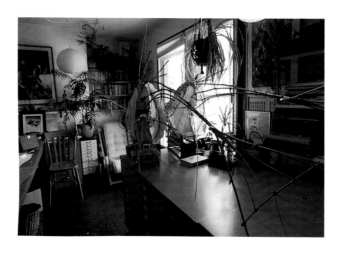

Delicacy of line and intricacy of detail typically characterize Ian Miller's work, though his subject matter and technique often vary greatly. Equally at home with complex machinery or living creatures of various guises, his illustrations range from loose figure sketches in pencil and charcoal to pen and ink drawings of complex artifacts, twisted trees or winged insects. In many of his pictures there's a sense of nightmare as a serpent rears its wedge-shaped head, a puppeteer sits surrounded by demonic-looking toys, or severed heads leer from the tops of barbed poles. What is always present is an element of the grotesque.

"I think that most of what I do has a very primaeval root. I've been told that I'm mediaeval, but I think I'm more primordial. I have a fetish-cum-totem attitude towards images — I try to describe them in the simplest, most direct terms. I think that's why I used to enjoy doing the drawings for *Men Only* and *Club International*. They were primary and emphatic images — the perfect vehicle for experimentation. Stifling a schoolboy titter, I was able to develop elaborate pattern-making techniques that carried over into my other work. I'm inclined to draw in a 'frontalistic' style, I suppose, after the manner of the Ancient Egyptians. The angles are never so acute or obtuse that people can't recognize what they're looking at".

Miller's mother was a theatrical milliner working for one of the leading costumiers to the film industry. "This connection brought an early introduction to the phantasmagorical world of film — a world from which I have never really chosen to escape. As a child, my toy boxes were littered with the paraphernalia from a host of films ranging from *The Black Prince* to *Sitting Bull*."

Born in 1946, Miller attended St Martin's School of Art in London from 1967 to 1970, originally completing a year of sculpture before transferring to the painting faculty. Earlier, while at Northwich School of Art, he had experimented with mixed media, painting at one point with concrete, but at St Martin's he developed a style using close pen work which arose as an offshot of his newfound interest in etching. During this period he worked predominantly in black and white.

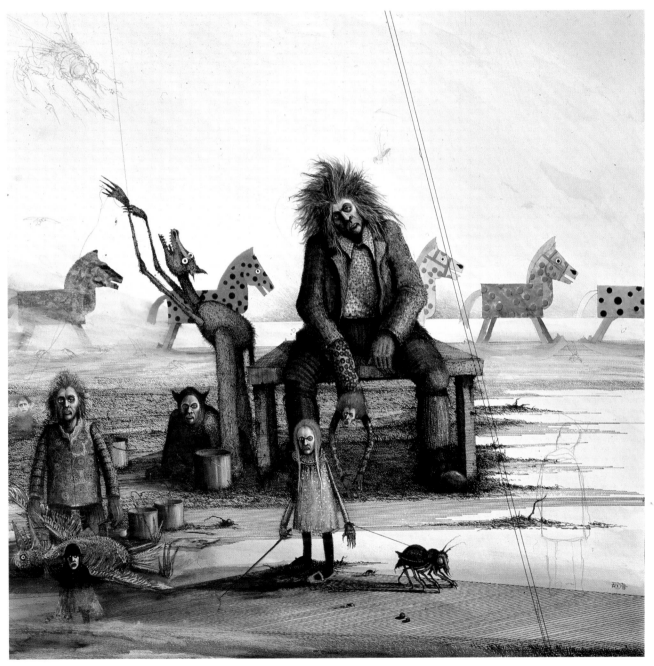

Death in the Rocking Horse Factory

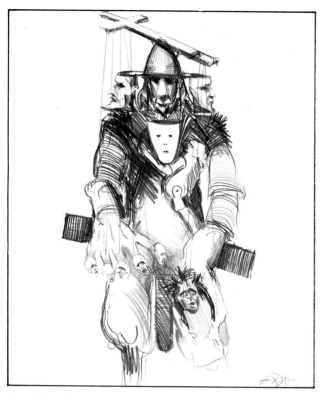

Pencil Drawing

"As a student in the transitory years of the sixties I identified very closely — I suppose I still do, though not perhaps in such naive terms — with the Japanese concept of 'The Fleeting, Floating World' and with the directness and unsullied perception of Japanese landscape artists. Their stoicism and singlemindedness is a great pointer for us all. It's magic from sweat."

On leaving St Martin's, Miller ensconced himself in his parents' garage for three months, never going out and devoting all his time to working on drawings with a Rapidograph pen. "When I finally emerged I had a folio full of landscape drawings. Somebody suggested that I should do the rounds of publishers and agents with a view to finding work, which I duly did. After weeks of trekking around, I was directed to one of the leading artists' agents at that time. He took me on and initiated me into the ways of the illustrator. In 1981 I joined Young Artists."

His earliest work included magazine and book-jacket illustrations. Later he produced his first book, *Green Dog Trumpet* (Dragon's Dream, 1979), which appeared without the text that was intended to accompany it, but which nevertheless has a strong narrative content. In fact, a typical piece of Miller's artwork is characterized by its sense of being a still or a single frame from some continuing piece of dramatic action. It has a storyboard quality.

"There's a storyline to all my work. I usually write out a theme beforehand to direct the images. I think most of my images have their source in the written word." Does the story change while he's producing the images? "Part of the discipline is trying to stick to the original story, but there's always some flexibility. I decided what I want to say, then I try to express that particular incident as dramatically as possible. What sometimes happens is that the drawing begins to grow beyond the terms of reference. Other elements creep in — sometimes to the point of clotting the illustration. The strangeness in some of my early work in some ways came out of an ineptitude rather than a skill. Some of the surfaces were originally there to camouflage poor draughtsmanship. Then they became a thing in themselves."

What artists have impressed him most? "I've never been one for hero-worship, but the two people I relate to most are Durer and Da Vinci. For me they represent those skills I aspire to — though that's not to say I didn't look to more contemporary sources, particularly the German Expressionists. Durer gives me a great deal. I have a book of his work that I often look at, no matter what subject I'm tackling. Perhaps the solution to the problem is not in there, but just turning the pages and looking at the paintings and engravings somehow primes me. I've also got Durer's *Rhinoceros* on a piece of plastic film which is always floating around. It's helped me a great deal."

Sketch for Stab·In·The·Box

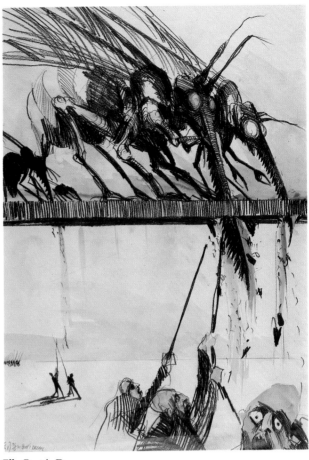

Elly Boop's Dream

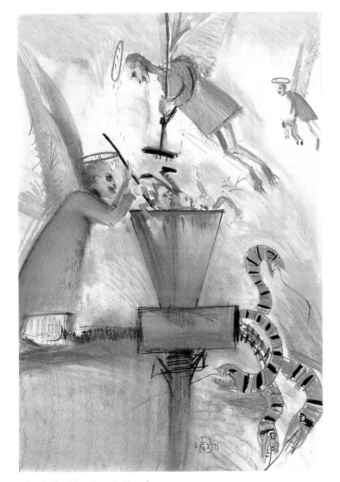

Sketch for The Angel Grinder

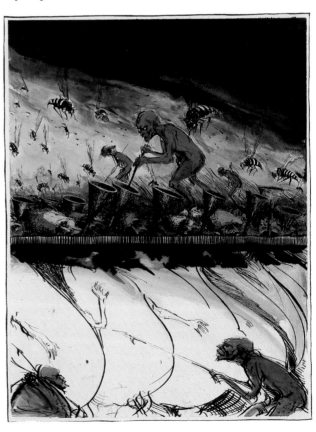

Trip To Hell Series

27

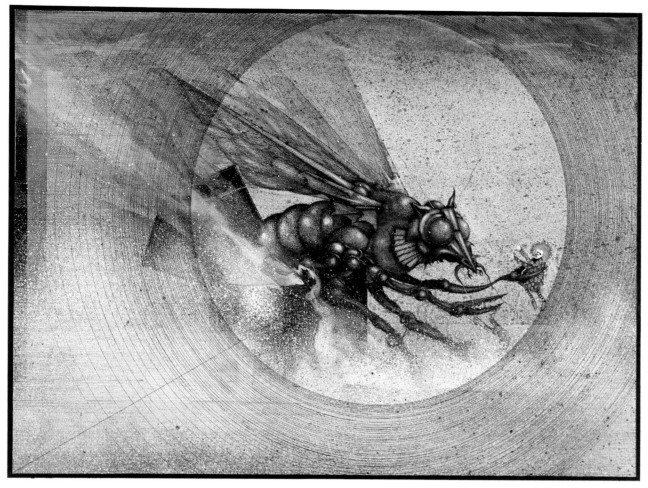

Hive Assault

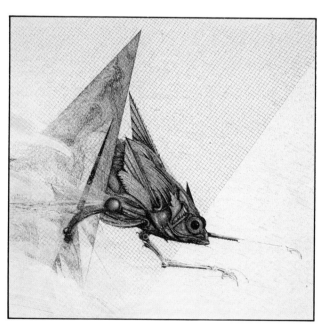

Fly

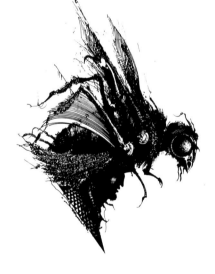

Durer had never actually seen a rhinoceros, and he illustrated it from a verbal description of the animal, his imagination filling in all the missing bits. "I think that's the best way. I work that way with reference materials. If I look at them for too long, they confuse me rather than assist me."

In recent years Miller has tended to concentrate on pen and pencil illustrations, often with limited colour. "I use Rapidograph pens with coloured inks, and a mix of pencil and watercolour washes. I'm also using charcoal. When I first began painting seriously I worked in what might be termed 'fairground hues', and this inclination to a rainbow palette has never wholly deserted me, though recently I have tended to more muted tones and in my present series of drawings to the use of black and red only. I used to paint in oils but got lost in the mystique and pretensions of it all. I found self-expression through the pen — with oils it was quite the opposite.

"That was a long time ago, however, and I feel now that the time is not long off when the facility of oil paint will offer a real and viable vehicle for my imagery. In the meantime I'm busily experimenting with pencil, which is without doubt one of the most vital of mediums available to the artist and yet paradoxically one of the most neglected."

Miller professes a continuing interest in three-dimensional work, and he's produced montages which he describes as "a need to explode the censorship of always working on a flat surface". Other illustrations are very small — no bigger than a large postage stamp — but they're still filled with detail. "It may be something to do with being short-sighted and being obsessed with surface. When I look around me, all I see is texture. Give me a smooth surface and I immediately look for the pock-marks or bubbles of rust."

How does an idea develop? "I'm very much one for extemporization of the caged variety — a kind of rioting behind bars." Does commercial work such as book-jacket commissions take him down different roads? "Yes, it does. Only now am I beginning to come to terms with commercial work." Because it's an imposition? "No, I've never seen it that way. It was more a case of trying too hard and getting into such a state about it that I all but neutralized myself. I'm detached enough now to keep this type of work in perspective, enjoying it even."

When doing cover art, he likes to read the book he's been given. "It gives you a source of reference, an an-

chor point. Once I've read the book I normally go through what I call hieroglyphics stage. I'll just think with the end of a pencil, rambling across page after page until something emerges that I can use. Having determined a specific image, the next thing is to prepare the paper size, according to the area I have to work in. That done, I think about image disposition — how I would like it to lie on the paper. In the past I always worked same size, but now I tend to do the original one-half larger than the required dimensions."

Does he work out a colour scheme? "To a degree, but there's a great deal of flexibility in what I do. Though I set the scene as it were, I try hard not to stifle the development process. You reach a critical point in any illustration when the picture begins to dictate terms of its own, and that's when the fun starts. If you're not quite together at this juncture you can spend hours or even days erasing and overpainting your way back on to the tracks.

"People are generally far closer to the creative process than some esoteric schools of thought would have them believe. If they directed their attention more to the actual process of image-making rather than allowing themselves to be intimidated and hamstrung by spurious precepts about what makes good art and artists, we would probably have a plethora of new talent and vital imagery breaking surface. Not having gone to art school or read Gombrich is not a handicap."

29

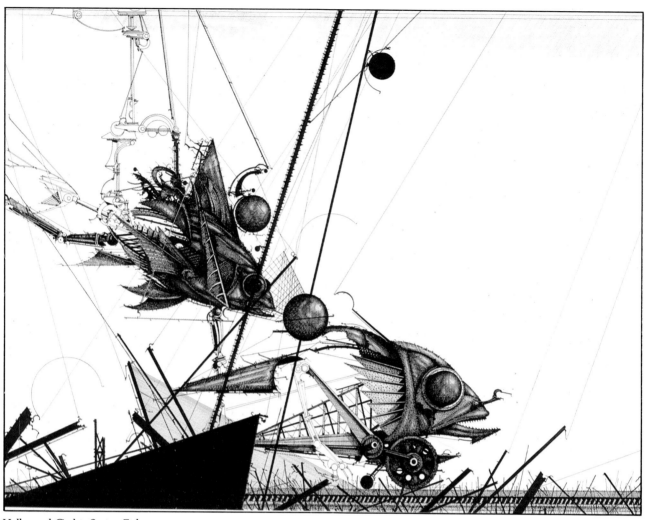

Hollywood Gothic Series, Fish

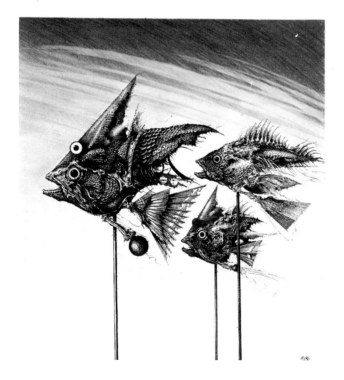

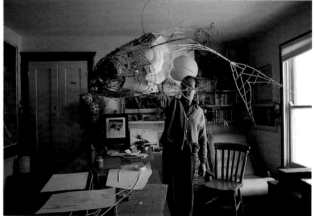

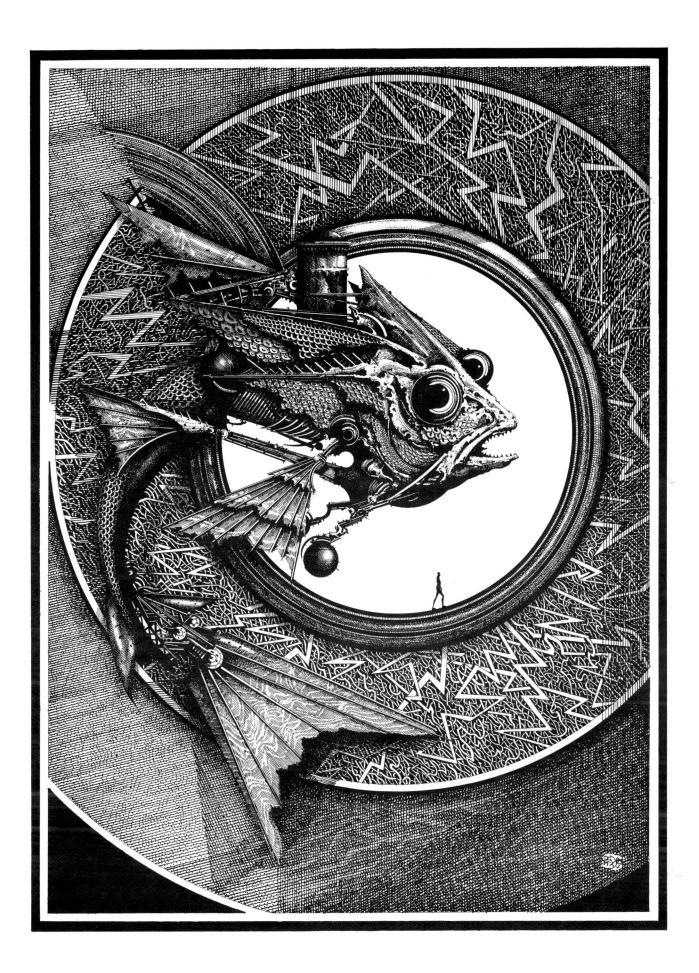

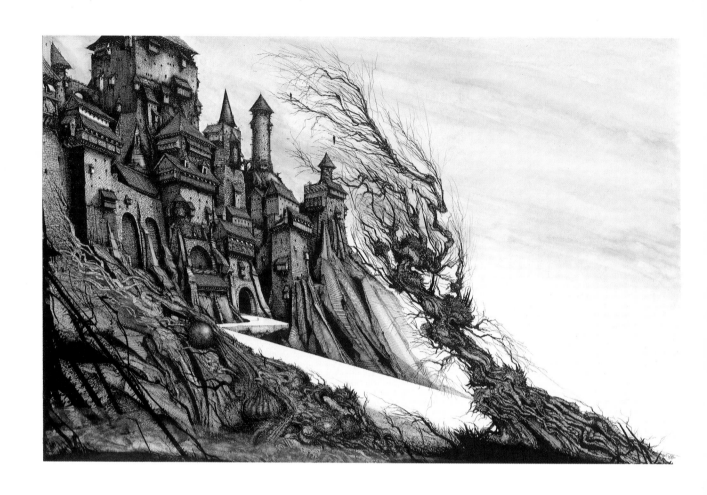

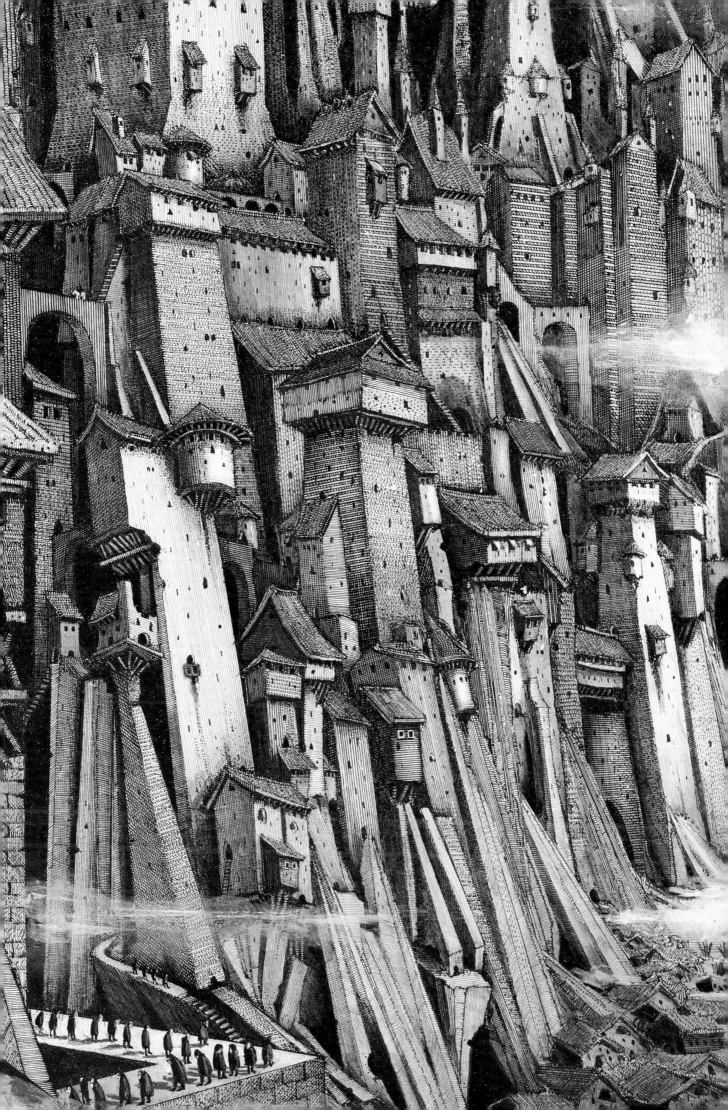

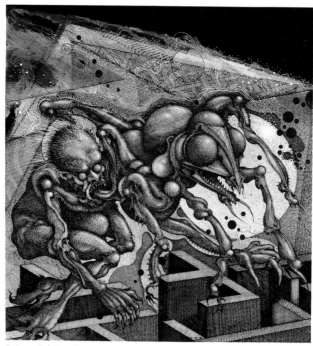

Maze Of Death

Does he get bored when doing the actual execution of an illustration? "I'm never bored by drawing. I think I do get hung-up sometimes by the problem of trying to over-achieve — demanding more from the material than it can possibly offer up in reality — a masterpiece at every stroke, as it were." He sometimes has the radio on when he's drawing, but finds that he works best in silence. A pen-and-ink drawing will typically take a few days to complete. "The further I get into a picture, the slower it becomes. When you've got plenty of space to play with, you can afford to make a few errors. But as the area begins to fill up, each line becomes that more critical."

There are recurrent images in Miller's work — for example, fishes, flies and a variety of robotic forms. Are they intended to symbolize anything in particular? "I suppose they must — a peculiar perspective on life perhaps. People are always imbuing them with forces and powers of vision that surprise me. That said, however, my images always seem to touch the edges where equilibrium gives way to discord and phobia, even when it's not consciously intended. I do work hard, though, to evoke a strong response in the viewer." He has reference books on mechanisms, and field guides to insects and fish. "I find them fascinating to look at. I'm not necessarily after a correct anatomical interpretation. I just want some idea of a form, to give me a jumping-off point."

In 1975 Miller went to Hollywood and did scene origination and background design for Ralph Bakshi's animated film *Wizards*. "I was left to myself to do as I would. I just lived in a studio and drew, and they fitted the animations around my drawings — until the end, when I had to draw established sequences of animation. Then I began to really learn, because I had to leave spaces for animated figures. Actually seeing things move — I never got over that. From a creative standpoint it was one of the most vital times in my career."

Miller enjoyed working with a team and would like to do it again. "It brought all manner of benefits, and tended to chase away the cloying sense or preciousness that often afflicts one's work in isolation. I found the corporate product utterly fascinating and came away from America with a far more robust and outward-looking attitude towards my work." Out of the experience came the "Hollywod Gothic" series of illustrations which show landscapes and figures as backdrops or props on wheels. "It started trends of thought which are just beginning to come to the surface now."

In fact, many of Miller's illustrations are part of a series in which a particular image will recur. "I see any image as a way of extending a process. If I'm trying to improve my technical proficiency I'll tend to hang on to the same image until I'm familiar with it. Then I can elaborate and embellish. It's like a permutation on a theme, really." At the moment he's doing a series of black-and-white ink drawings of fish. "It's not that I'm overly interested in fish themselves. It's just a vehicle. I'm fascinated by the whole illusion of creating depth and solidness. By putting down veneers and lines you build up this new reality. It never ceases to amaze me just how one arrives at these particular effects."

34

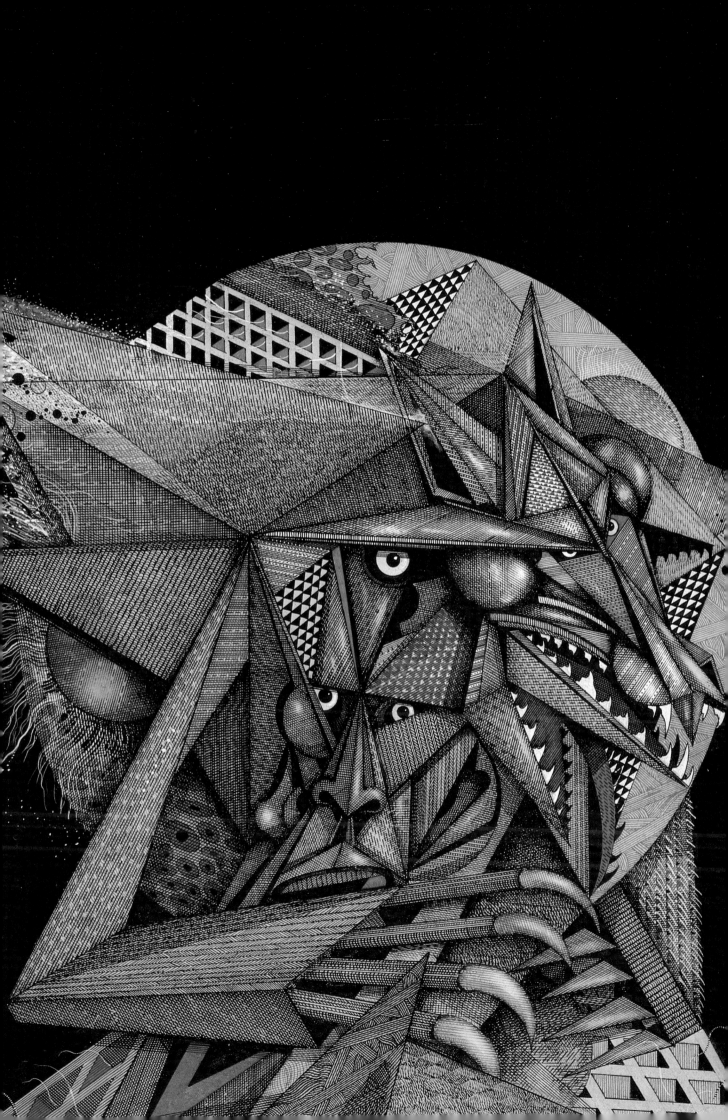

Patrick Woodroffe

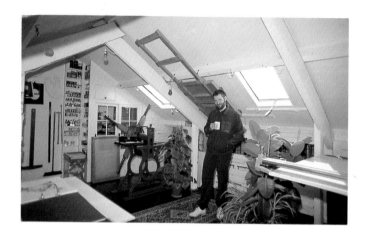

"Art is about romance, I think. It's about giving some sense of mystery and wonder to things — to colour the way we look at the world. Doing what reality can't do makes the art stronger. I like to skirt the edges of kitsch because I think that's where some of the best art comes from".

"I see myself primarily as a thinker, not necessarily an artist. Drawing and painting is just one way of doing it. That's why I write as well. The two things go together. Most of my drawings and paintings are like stories — there's a little incident happening in them, or a thought there. None of my illustrations are just views without some sort of comment or narrative content. I could quite happily just write. But it's the illustration that makes the writing more personal. The images are in my head and I just want to bring them out and make them more real."

One of the most striking features of Patrick Woodroffe's art is its richness of colour and detail. Mellow browns and golds combine with cerulean blues, lush greens and fiery reds in a way which enhances an often striking juxtaposition of images. Figures, buildings and the natural features of landscapes stand out with great clarity so that it is possible to see every leaf on a tree, every feather on a bird's wing, every hair on the chest of a muscled warrior.

"That's the way I see reality. One of the thrills of looking at nature is that everything is so incredibly sharp and real. No matter what you do — whether you photograph it or whatever — you can never convey that incredible super-reality. But the more detail

you put in a painting, the longer the illusion lasts, even when it's a pure flight of the imagination."

Over the years, Woodroffe has worked in a variety of mediums — watercolour, etching, engraving, sculpture in wood, metal and glass, and cut-out pictures which he calls "tomographs". In addition to illustrated books, he has also produced book jackets and record album covers. But more recently he has tended to concentrate on oil paintings for his book projects, returning to the traditional artists' materials of steel pens and sable or hogs-hair brushes. "In the past I've used airbrushes and Rapidograph pens, but although I was enthusiastic at first, I don't use them now. I tend to find that the old methods are the best."

Woodroffe started late in life as a serious illustrator. he had no formal artistic training, and painted as a hobby for many years, only starting to make a living from his illustrations when he was in his early thirties. Born in Halifax, Yorkshire, in 1940, he graduated in French and German at Leeds University. Now he lives in Cornwall with his family, having abandoned intermittent teaching in 1972 to become a free-lance illustrator. That same year he had a successful exhibition at the Covent Garden Gallery in London.

Despite this, it didn't prove easy to find customers for his work at first. "I went through years of travelling up to London from Cornwall, taking my paintings with me in a crate on wheels and trundling it across Hyde Park to the West End galleries. I got completely ignored. Later I hawked my portfolio around publishers, and was endlessly turned down by them." Eventually, however, his persistence paid off

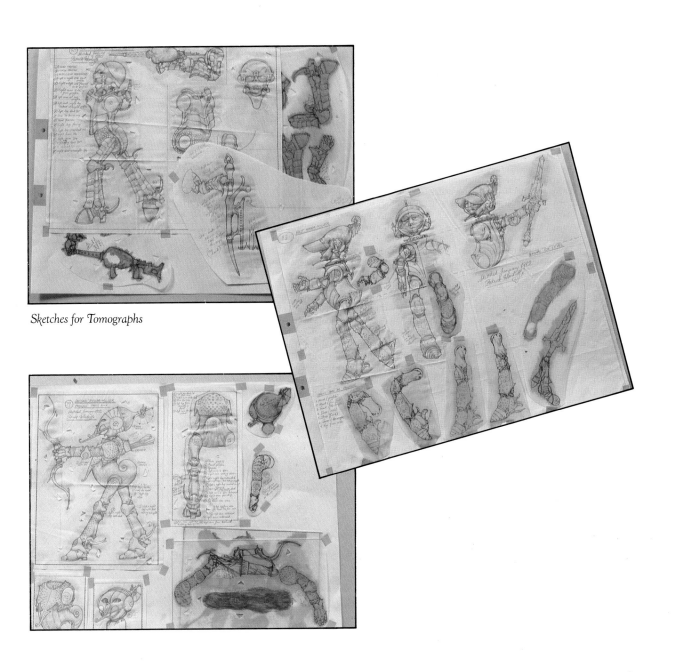

Sketches for Tomographs

with cover illustration commissions, and soon he was booked up for months ahead and had to turn work down.'

"It wasn't until I started getting problems with book covers — having to make changes to the artwork — that I decided it wasn't worth the effort. I put on a show of all my book covers at a gallery run by the cartoonist Mel Calman in 1976. Although I hardly sold anything, it did give me the opportunity of doing the book *Mythopoeikon*." *Mythopoeikon* featured a wide range of Woodroffe's paintings, etchings and illustrations, and he wrote his own commentary.

Since then he has concentrated on producing artwork for book projects. While painting, he bears in mind that the illustration is for reproduction, though he's not satisfied unless the illustrations can be looked at closely as they are. "I don't really see why there should be a distinction between artists and illustrators. For me, most of the best artists are illustrators anyway. Some people describe a painting as 'literary' as if it were an insult. I don't see why you have to be very abstract or self-effacing to produce something worthwhile."

He usually paints in oil on the smooth side of hardboard masonite. "I have used plyboard, but hardboard is as good as anything else if it's properly braced and properly primed. Correct preparation is absolutely fundamental. I prime the board at least six months before I paint on it. If you use an oil-based ground too early, it alters the way the paint goes on. After priming, I rub the board down with very coarse-grain sandpaper. You have to be scrupulous about grease. I never touch the ground with my fingers, and I always rest my hand on a sheet of paper, whatever I'm painting. It's a good habit never to touch the paint surface."

Once the wood is primed, he draws a sketch on it with a very hard — 9H — pencil which enables him to put in fine details. He does the actual painting in two stages, doing an underpainting which he then leaves for six weeks before applying the second coat. "It's essential in oil-painting to be systematic. Things can got disastrously wrong if you don't follow the rules. It's a good idea to use warm colours in the first coat of paint because reds are hard to get on afterwards, whereas blue is very easy to put on top of red. I tend to use as many earth colours — burnt sienna, india red, raw umber, etc. — as possible in the underpainting. No blacks, because they're easy to acheive later,

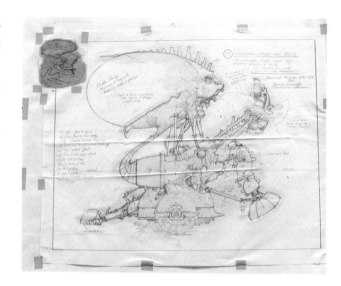

Construction of Tomographs

though in fact I hardly ever use blacks myself — they take a long time to dry and they deaden a picture. If I want a black effect, I usually use a blue or a bluish-brown on top of something else.

"Basically, the final effect I want to achieve is not possible in one coat of paint. In most paintings you're seeing through the top coat to the layer of paint below. The best blues always come with white light shining underneath through the blue. So if you mix, say, cobalt blue and white, you'll get a fairly good blue, but it'll be a "muddy" blue, whereas if you glaze your cobalt blue over an existing layer of blue or white, you'll get a much better intensity of colour. By doing two coats you can also get interesting effects using complementary or incompatible colours. You can use bright red and blue close together without any possibility of them mixing."

Woodroffe uses only volatile thinners for the underpainting — genuine turpentine or petrol or oil of lavender. "An advantage of mixing oil paint with turps is that it becomes quite runny but soon stiffens

Painted Tomographs

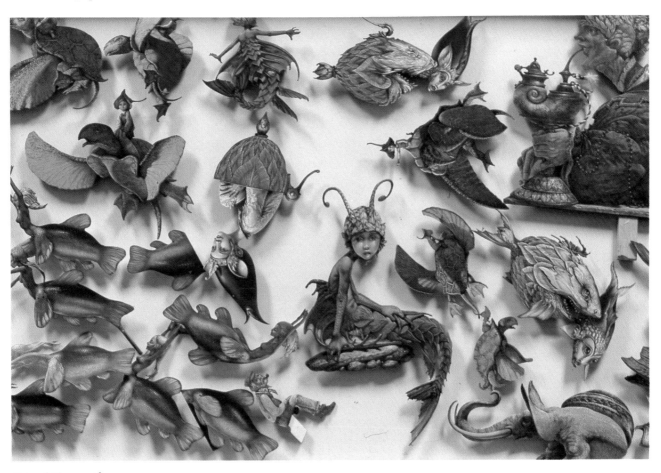

Painted Tomographs

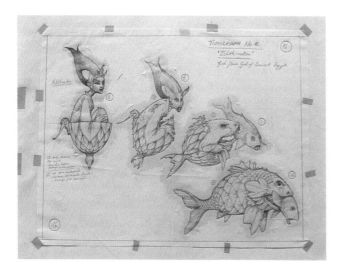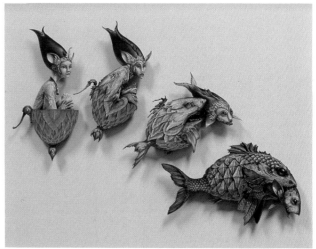

up after you've brushed it on. You can then still fiddle around with it — it's still movable, but buttery in consistency rather than runny."

The underpainting uses relatively little pigment, and Woodroffe's main concern at this stage is with light and shade. It's quite a quick process, but he gives the paint plenty of time to dry and works on other illustrations in the meantime. For the second coat he uses a mixture of oil paint and a synthetic oleo-resin. "It's rather like painting with varnish — you get a very controllable glaze. Nothing's quick in oil painting, but the secnd coat is usually touch-dry within a day." He finds these techniques not only effective but also relatively cheap. The earth pigments and the whites used in the underpainting are the cheapest colours, while the more expensive glazes are applied thinly on the second coat, which provides the highlights.

Is the composition and design affected by the medium he's working in? "Yes. With oil-painting you can make everything very real because you have enormous potential for contrast — far more than is possible in any other medium. You can go from a saturated, glossy black to a very strong white. Or all the colours can be used very opaquely." Though the colour and detail of his paintings are rich, the texture is reasonably flat. "It has to be. If your first coat is too thick, it takes forever to dry. I find working with thin layers of paint much easier than thick ones. I only use thick paint if I want a particular effect."

How does he actually get the image he wants to paint in the first place? "Most of the time I keep my mind closed to new ideas when I'm working on a particular illustration. But when it's time to consider something new, the flood-gates open and the ideas just pour out.

They seem to come from somewhere else, as if they're waiting to be found. I don't edit them but try to get down what I can. I start to visualize things when I begin scribbling on paper, and it leads off in unpredictable directions. For example, I'll think of a fan shape and I'll just start doodling around, putting in some oddment like an eye. Suddenly a surge comes and I'll see a vision I can explore. I never find that I've got an idea in my head beforehand which has to be put on paper. For me, the visualization grows on the paper itself."

The original pencil sketch usually becomes the final work, and he sees this as the really creative phase, requiring silence and total concentration. "But once the drawing's done, from then on it's basically the manual labour of painting, requiring only minor decisions about colours, shades, etcetra." At this stage he needs something to occupy the other half of his mind while he's painting, so he listens to music. "Otherwise I tend to brood or get tense about it. I have to be quite entertained to do the long hard slog of actually getting the work done."

Normally he works a nine-to-five day and takes weekends off. He finds he works best in the morning after a walk or a training schedule. At midday he takes a short lunch-break before working on until 2pm. Then he spends an hour walking or bicycle riding before returning to work for the rest of the afternoon. Conscious of the sedentary nature of painting, he enjoys exercise and likes to vary his days by doing different sorts of work. His studio contains not only drawing and painting materials but also equipment for doing etchings, engravings and typography.

"I'm fascinated by doing different kinds of work.

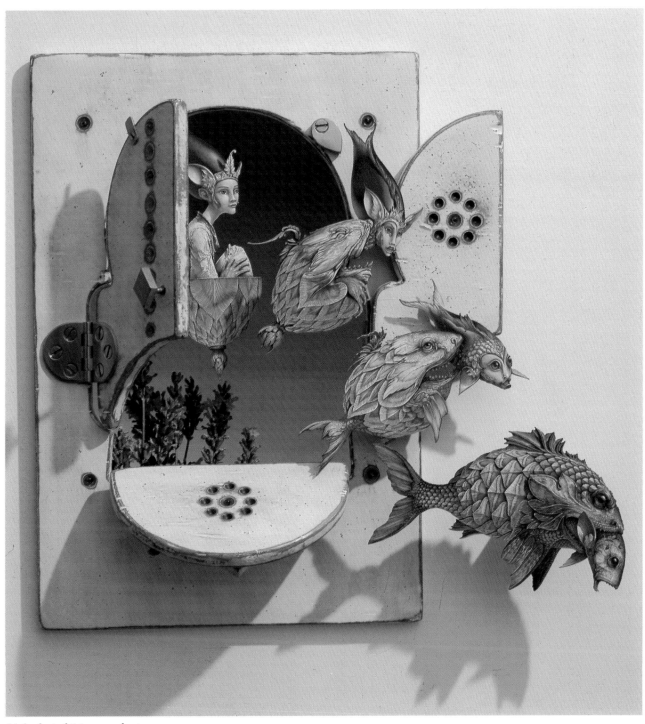

Ichtheological Metamorphosis

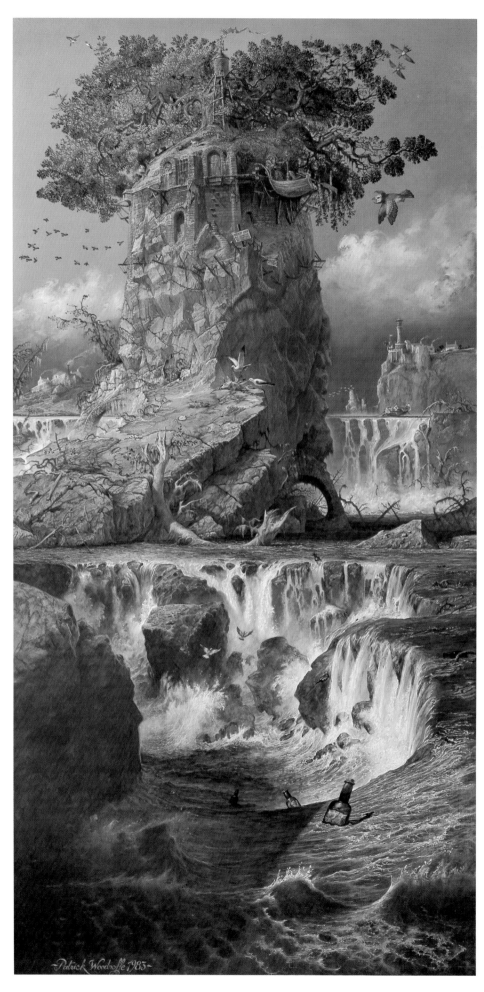

Hortus Conclusus

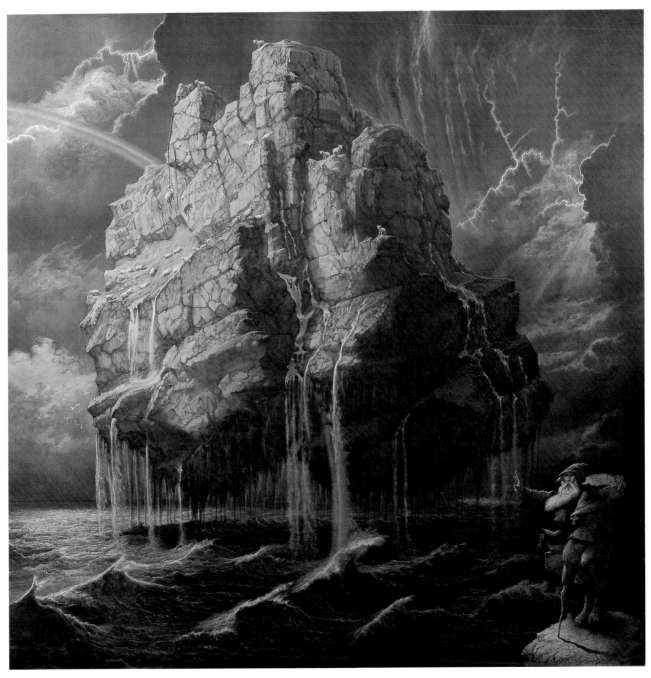

Mons Veritatis

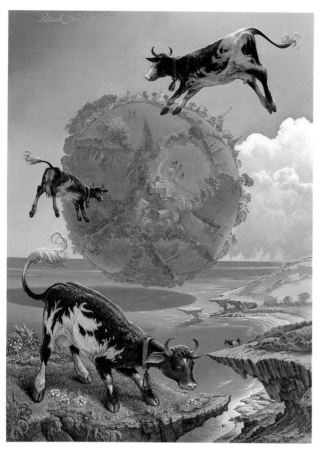

Pastures In The Sky

There's nothing more dreary than sitting at a table painting every day. Any excuse to do a bit of typesetting of something different is welcome."

Does he use any visual references for his illustrations? "I used to when I was doing book covers, but not now. For some years I've deliberately chosen never to use any form or reference or to paint from nature. If an artist can do anything that's unique, it comes from getting it slightly wrong — that's what gives the work its charm and "romance". The way I draw figures now is anatomically incorrect, but somehow it fits in with the image. I think a lot of artists make the mistake of believing that correctness is important. I build on the fact that it's wrong. A lot of painters have done that in the past — particularly in mediaeval times, I suspect."

In fact, much of Woodroffe's work has strong affinities with Moghul or mediaeval miniatures. He acknowledges that Flemish primitive painters such as Bosch and Brueghel influenced him, but he also cites such diverse names as Arthur Rackham, W. Heath Robinson and Salvador Dali. Landscapes are very powerful in his paintings, and there's the recurring motif of flight or levitation. "I think it's a symbol of joy as well as freedom. It's also a pictorial consideration. I like to put something in the sky, otherwise there's nothing there. It's also fascinating to play with the fact that it's possible to do that. Like most people I'd love to be able to fly." Coastal landscapes also feature strongly. "What I like about coasts is that you've always got a horizon — a flat line which gives discipline to a painting with lots of crazy things happening elsewhere in it."

He paints most things horizontally, on a table. He has a German agent for selling second rights in his books and illustrations, but prefers to deal direct with British markets himself. The time spent on a painting will depend on its size, though it may be as little as a week.'

The Corn Fairy

44

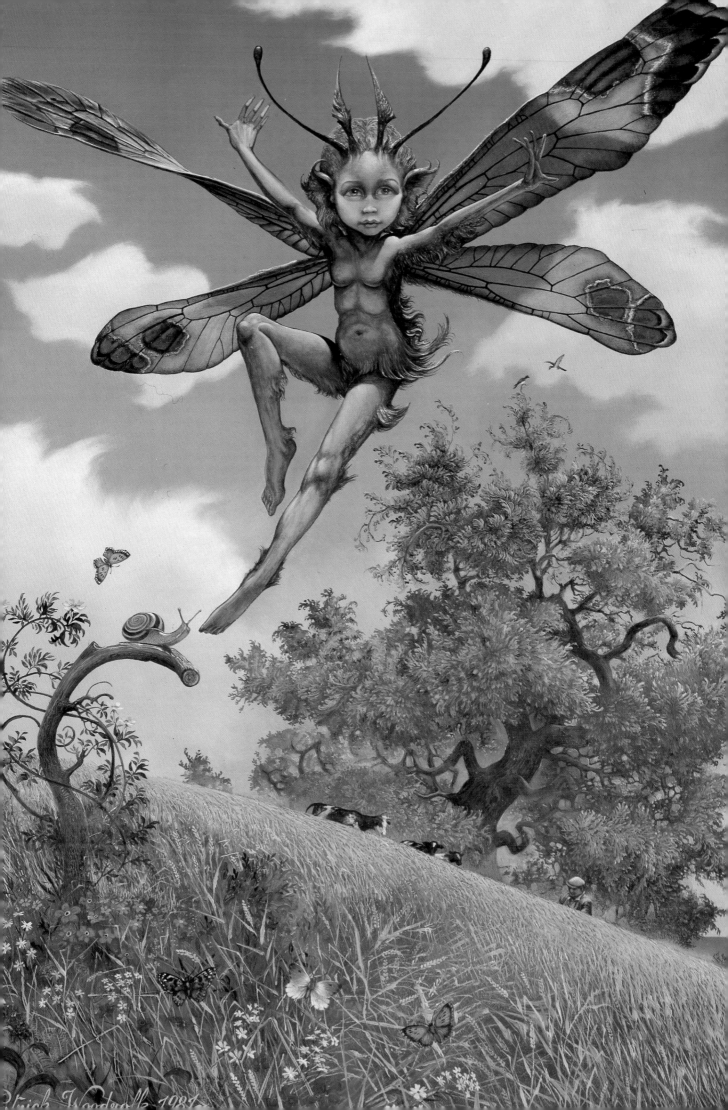

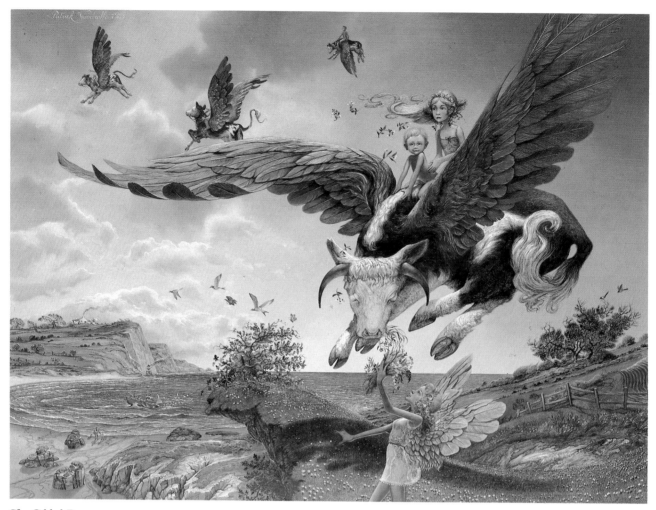

The Gilded Doorway

46

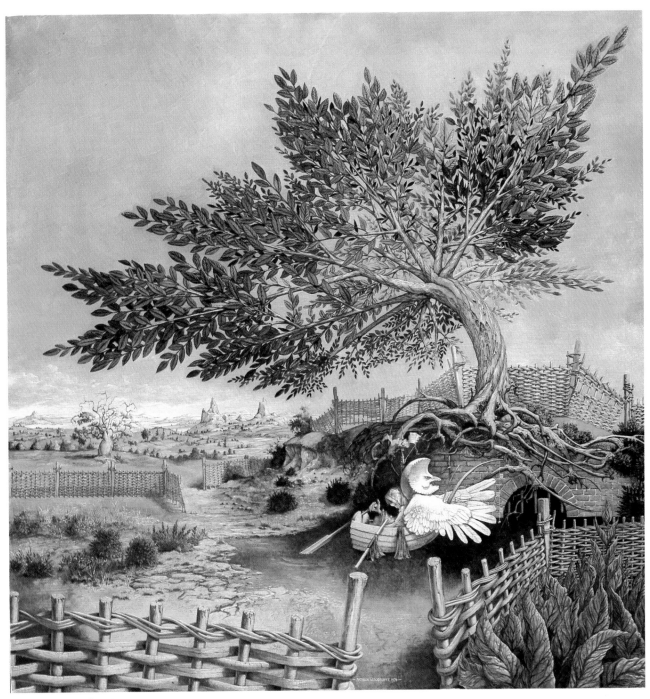

Within The Wicker Fence

How does he relate to the public? "I definitely see my paintings as a form of communication. I love it when people react to them. But it's a take-it-or-leave-it thing, I'm afraid. If I found that what I was doing wasn't popular, it wouldn't alter what I do. I view myself as a romantic painter. I'm not acceptable in the art-establishment fields, but I have the compensation that a lot of people out there like what I do."

He doesn't usually sell his paintings and views all his work — whether it's a very personal book project or an album cover for a rock group — as something which he does for his own satisfaction. "I don't really think about what it's for. It's just life for me — it's what I do."

The Dry Land

Philip Castle

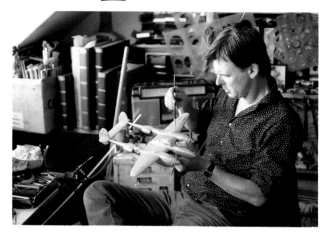

On summer weekends Philip Castle goes to airshows where he takes photographs and makes films. "You get absolutely beautiful shots with the sun glinting on the 'planes." He also photographs exhibits at air museums all over Europe and America. At home he has files of thousands of photos and magazine pictures under headings such as "Arms, Legs and Mugs" or simply "Things"; scrapbooks of car advertisements from the 1920s onwards, collected since his schooldays; and scores of die-cast toys in which American automobiles of the 1930s and 1950s predominate. He has also attempted to recreate the USAF in plastic with over 100 jet 'planes built from kits, sprayed silver, "and now gathering dust." These are the raw materials from which Castle creates his very distinctive art.

Castle is not only a master of the airbrush: he can also claim to have originated its use as a tool of the serious artist. He discovered the instrument in the early 1960s while studying at the Royal College of Art in London; it was lying unused in the typography department. Prior to this he had been trying to achieve the smooth effects of the airbrushed car advertisements in his collection by using ordinary paint brushes, careful washes and coloured pencils. At this time — 1964 — the prevailing illustration styles were 'Paul Hogarth' type pencil sketches and thick line-drawings originated by Milton Glaser and the Push Pin Studio where the spaces between the lines are filled in with flat colour — a sort of "stained glass" effect. It was in this manner that other early airbrush illustrators of the 1960s used the instrument. Castle was after a more realistic look, his

achievement was that he saw the potential for skillful creative picture making by using the tones and shades which could be produced with the instrument. As with any pioneer, he had to teach himself by trial and error. He established a style which has been universally adopted, but he still remains one of the foremost exponents of the technique.

For many years Castle worked exclusively as an illustrator, painting for most of the big European magazines, producing posters for advertising agencies, album sleeves and logos for rock groups, paperback covers and movie publicity material. He did the celebrated poster for Stanley Kubrick's *A Clockwork Orange* and the famous advertising billboard which shows the droopy ears of Mr Spock from *Star Trek* being replenished by a draught of Heineken beer. But in recent years he's produced his own ideas for gallery exhibitions, and it's in these pictures that we see an undiluted expression of the imagery which fascinates him.

Three elements recur in Castle's paintings, and in order to distinguish his own work from what he calls "airbrush cliches", he describes these subjects as "Flying Scenes", "Dream Cars" and "Chromed Angels". The first of these developed from his early passion for aeroplanes which began at about the age of three when his father returned from the RAF. "He was a carpenter, and they persuaded him to mend their shot-up Mosquitoes (the Wooden Wonder). He brought back lots of Air Force paraphernalia, including books and a silver model of a P-38 Lockheed Lightning which I thought was so beautiful. I filmed

Philip Castle's Studio

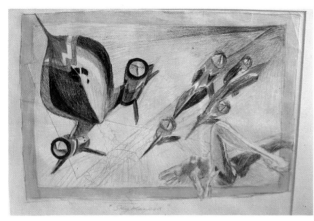

Colour Roughs

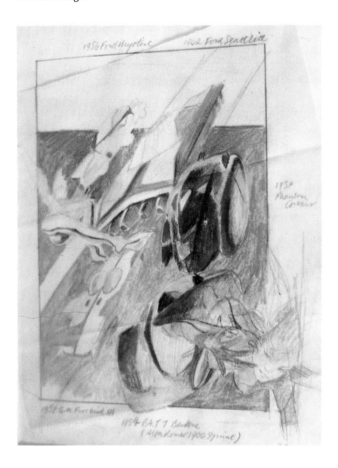

one flying in Texas two years ago, and seeing it in reality proved to be just as exciting as the model I adored in 1947."

Castle was born in Yorkshire in 1942 and attended art school in Huddersfield before going on to the Royal College. As a child in the 1950s his imagination was stimulated by Frank Hampson's "Dan Dare" in the *Eagle* comic, by U.S. movies with their evocative images of the American Dream, and by his 10 year subscription to *The RAF Flying Review.* His art college training followed in the sixties, and the flavour of that radical decade also colours his work. Though he's part of no school, his pictures have the immediacy of the best kinds of pop art with their striking conjunctions of disparate images. He's always enjoyed contemporary music and has done illustrations of Johnny Cash, Elvis Presley, Dolly Parton, John Lennon and others. In most cases these portraits were "mechanized" in some way so that Cash holds an automobile tailwing instead of a guitar, Elvis becomes a juke-box and Parton's breasts are transformed into aircraft nacelles.

"When I left the Royal College in 1967 I worked continually on commissioned work, and this prevented me for ten years or so from painting my own ideas. When I was offered a one-man show in 1977, I decided to cut back on the 'commercials' and put together a collection of these ideas.

"Many of the images I wanted to create involved flight — a subject which I considered had been largely ignored in art. My picture "A Break in the Traffic" (1977) was the first such painting, and it represents a release from all the pressures which had built up while I was working for other people and trying to interpret their instructions. The picture shows a flow of flying machines — two F-16 Flying Falcons in 'Thunderbird' livery, formating with a traffic jam of *Dream Cars.*

"Idea or Dream cars are built by the automobile manufacturers, one copy only, to try out their stylistic fantasies, however bizarre or ostentatious. The golden age of these Idea Cars was between 1938 and 1960, the years when Harley Earle was head of Styling at General Motors in Detroit and the great days of Pinin Farina, Bertone and many others in Turin. I have always collected pictures from magazines of these cars since they first appeared, so I had quite a collection in 1967 when *The Sunday Times* asked me to illustrate a number of them for a

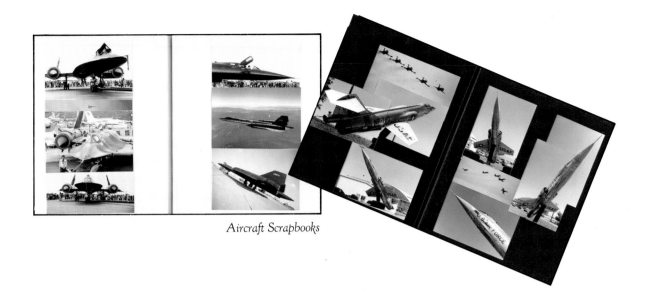

Aircraft Scrapbooks

six-page spread in the Motor Show issue of that year. For my exhibition ten years later, I decided to paint a collection of pictures of Dream Cars as my tribute to their designers."

Castle has had three major exhibitions in 1978, 1979 and 1981. Since then he's set aside more time to work for himself, though he continues to do commercial work and appreciates some of its benefits. "In commissioned work one always has to do what is asked, but I always do it in my own way. It is good occasionally to have people come up with a suggestion that I would never even have dreamt about myself. Suddenly I get into the flow of it and I can get a great deal from it. I suppose I wouldn't want to be cut off from this. But in any commission, you are watering down your ideas to some extent. Even so, my actual dedication is just as intense as it is in my own work. I don't consider it any less worthy. I wouldn't take the job in the first place if I didn't think I was going to enjoy it."

At art school his scrapbooks of car advertisements gave him the idea of "chroming" things. He chromed lettering, thus creating a style that was extensively copied. "A college project to paint a portrait of the Queen allowed me the opportunity to chrome Her Majesty. I presented it as a 1965 car advertisement — 'Monarch 65, Wouldn't You Really Rather Have a Buick?' The next opportunity to mechanize a human was my Elvis Jukebox, painted in 1970 for the front and back covers of a book. I had had the idea and made sketches for a chromed woman for a long time, thinking it would make a great poster. Another cover assignment for Tom Wolfe's *The Kandy Colored Tangerine Flake Streamlined Baby* gave me the chance to try it out." The finished art showed a girl whose bare breasts blend into a chrome panel which combined elements of car hoods, propeller housings and jet-engine nozzles. "This idea was refined later in the painting 'Truly Trionic', and the concept of half-flesh, half-metal creatures has developed in my pictures ever since."

His choice of subject for a painting evolves through time. "I like to play with the name of an aircraft, for example, and build up a striking image incorporating that 'plane and other elements to make an interesting

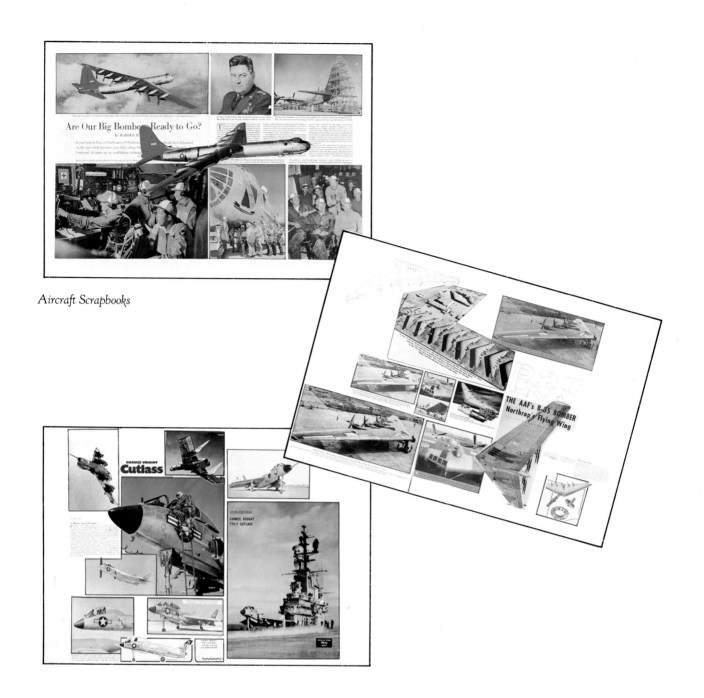

Aircraft Scrapbooks

painting. Just as I have a desire to paint a car by a designer or stylist whose work I admire, so I will be drawn to a personality I admire. The recognition of the person is a further sensation in the viewing of my picture."

He begins a painting by doing pencil drawings. "I try a lot of different views and angles to get the one I want. I try to decide on the best positioning of each element and then freeze it and do the whole drawing properly." He uses photographs for reference and will even assemble a model aircraft if he's unfamiliar with it before making reference Polaroids.

Once the basic design has been decided, the next stage is cutting the mask out of transparent film preparatory to airbrushing. A given area to be

sprayed is cut out and the tone and colour gradually built up until the desired effect is achieved. When the paint is dry, a section of the film is replaced so that the paint is protected but still visible. Another area is then exposed for spraying.

Castle uses a lightweight board which is hard and smooth so that even marker pens or oil-based fibre-tip pens won't bleed on it. He does most of his airbrushing with watercolour, mainly poster paint. "Poster paint is flat and dries immediately so that the surface is easy to manage." He has a variety of De Villebis airbrushes for different sorts of work, ranging from big industrial instruments like mini sprayguns for covering large areas to a Pasche Turbo which produces very fine lines.

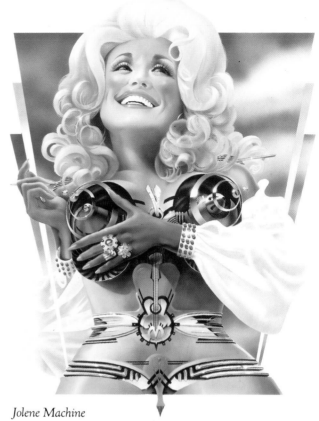

Jolene Machine

For commercial projects Castle tends to work on a smaller scale because the jobs have to be done within a set time limit; a billboard poster might be blown up from original artwork only 36 inches wide. "For my own paintings I love working big. On a smaller scale you can't get the same quality of detail. I like to see my pictures framed, and the bigger they are, the more impressive they look. In terms of technique, though, it's more difficult — it takes a long time to cover a large space with an airbrush."

How does he tackle the highlighting, shading and so on? "I work it up from being white to dark. If something goes wrong, I have to spray white on it before I can change it. I can't just put any old colour over another." Does he have to do much repairwork after masking as a result of splashing or bleeding under the film? "No. I don't usually have accidents like that." In his early days he used to draw on cartridge paper and cut out each shape like a jigsaw before weighting down the bits with pennies. The fuzzy edges obtained by this method were not necessarily displeasing. If something goes drastically wrong, he will as a last resort cut out the section and make a montage.

Castle feels that it's important to allow enough time to do a painting; each work takes from three to five weeks. "I love starting a new project — finding the reference material, doing scores of preparatory drawings, choosing angles — it's all exciting stuff. When the picture is on the board the actual airbrushing can be boring, but once I reach the stage where I can take the film off, I'm usually feeling very good about it. The finishing-off process takes me as long as the initial airbrushing. It's what brings the painting alive."

For putting in fine details he uses paintbrushes, marker pens, coloured pencils — anything which will give him the effect he wants. Lines are drawn in by hand. He likes to try new products as they appear on the market and has found very fine felt-tip pens useful. In general, though, he tends to stick to the methods and materials which work best for him.

When the picture is finally complete, Castle sprays on gum arabic as a protective covering. Finally he has to think of a title for the painting. "What I like is for the picture to be framed in a gallery or printed and for people to react to it and wonder. Then they come to the title and it makes them smile. I think that's a nice kind of end-product to the process!"

Apart from the occasional painting for close friends, he sells all his private work through the Francis Kyle Gallery. Is he good at imposing his own discipline when working on an exhibition? "I have to stop commercial work completely just because of the time it takes to do one of those pictures. It demands a lot of

Scrapbook

self-control to turn down a commission. I'd like to stress that I never do a painting with a market in mind. I work entirely for myself. But if a painting does strike a chord in other people, then I feel the process is complete."

Familiar female faces appear in many of Castle's paintings — Rita Hayworth in "Roving Redhead", Brigitte Bardot in "French Collection", Debbie Harry in "Disassembly Line". For "Roving Redhead" he took shots of a Liberator bomber out in the Arizona desert with a 1000mm lens so that everything was squeezed up, with the nose and dorsal gun turrets close together. His original idea was to have Rita Hayworth cutting her way out of the aircraft with a blowtorch. He tried a few varations before deciding on the finished design.

"The design charcteristics of the female form are naturally attractive to me, both as a man and a painter. The connection between woman's bodies and the reason for certain design features in the cars I paint has not escaped me, but the inclusion of this third element in my pictures is not quite as straightforward as it may seem. I became interested in the 'pin-up' motif indirectly through my passion for aeroplanes. It was the bomber-nose art which intrigued me, where fliers decorate their craft with copied paintings of Vargas and Petty pin-ups. I sought out the originals and was impressed by the artists' techniques and painting skills — I formed a collection of their pictures whilst at art school. It was always my plan to make paintings based on this connection between women and flight. Thus my third element, "Chromed Angels", came into being."

Is there any significance to the particular women he uses in his pictures? "They're ones I like. It's as simple as that. In 'Disassembly Line' the face just happens to be someone we recognize." Similarly the cars and aircraft are chosen by Castle for their aesthetic appeal to him. Castle takes them and makes them more vivid and real than photographs. The symbol becomes larger than life, and it's no coincidence that in many of his paintings the images are positively bursting out of their frames.

56

Car Mascots

57

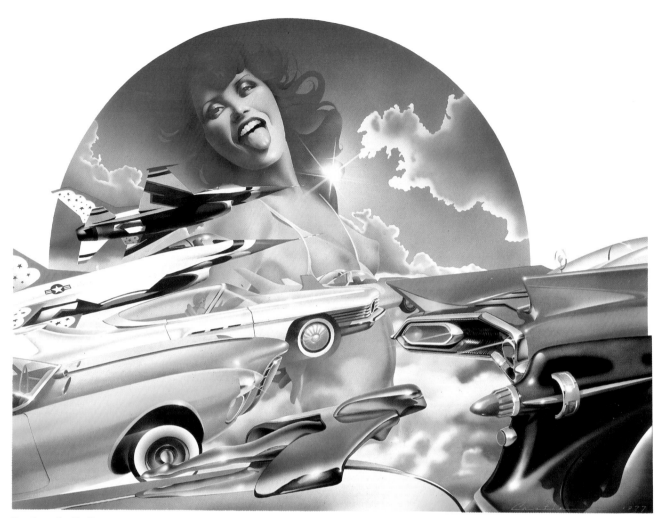

Break in the Traffic

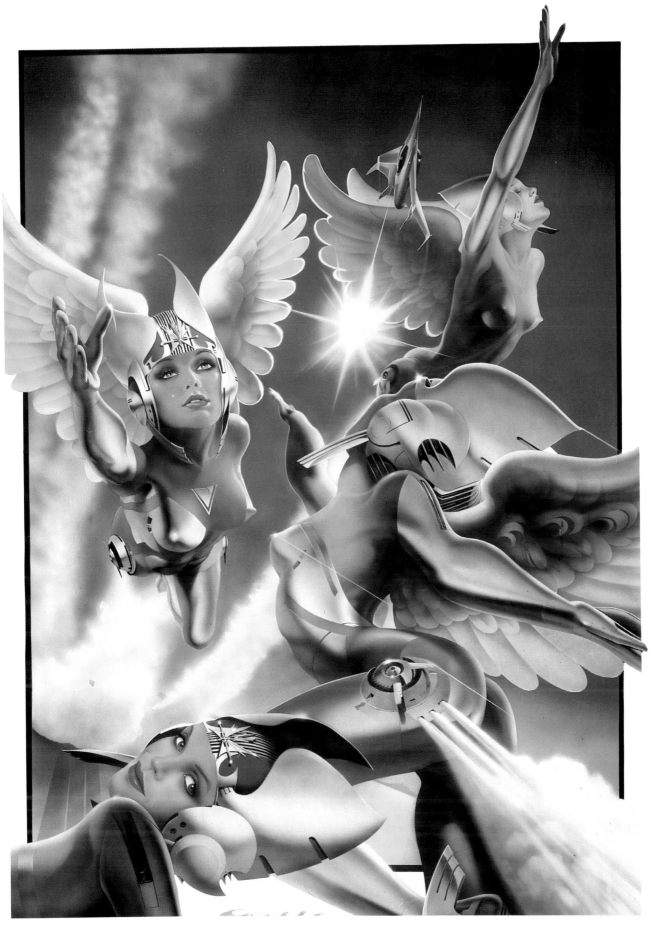

Chrome Angels

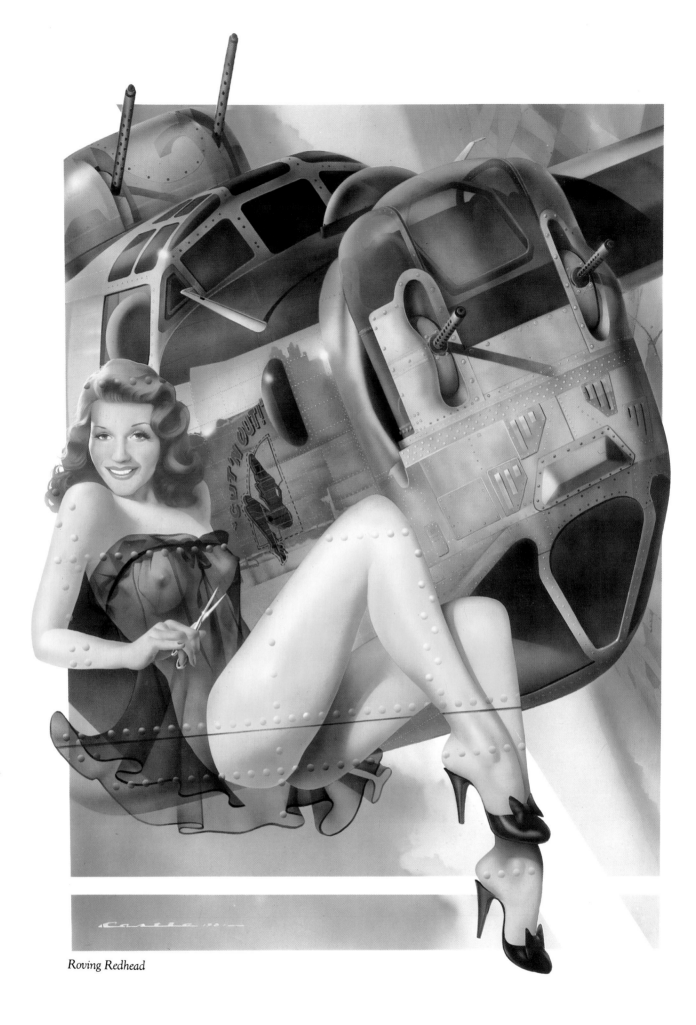

Roving Redhead

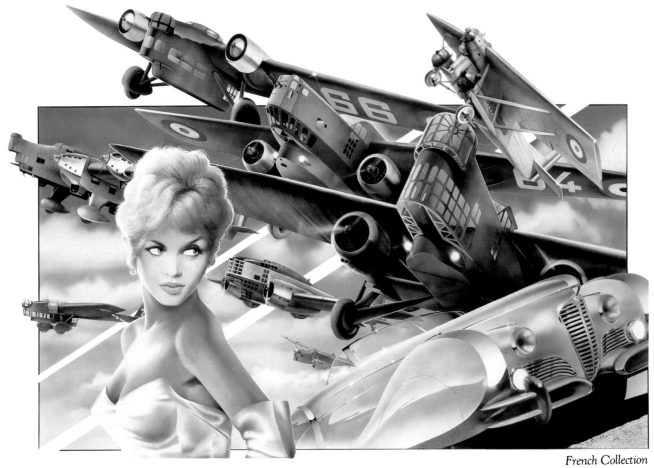

French Collection

61

Syd Mead

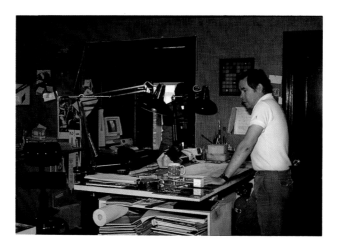

Syd Mead's screen credit on the move *Blade Runner* was "Conceptual Futurist", a term which offers a hint of the scope of his abilities. Head of his own industrial design company since 1970, Mead has long been a highly sought-after illustrator for clients requiring futuristic designs which are firmly based on technological possibilities. In this capacity he has produced visualizations of everything from trucks to helicopter interiors, from luxury yachts to science-fiction movie hardware.

Born in St Paul Minnesota, in 1933, Mead became interested in Fantasy Vehicles at an early age. Later, while serving in the army, he sent some automobile designs to the Ford Motor Company and received an encouraging letter from a chief designer suggesting that he attend art school. After his army service, Mead majored in Industrial Design at the Art Center School in Los Angeles before going on to work for Ford and US Steel. With his flair for realistic extrapolation, he was employed by both companies on advanced design projects. A US Steel promotional book entitled *Concepts,* which featured his illustrations, brought him international recognition as a designer, and further showcases of his work were published in the years that followed before he formed Syd Mead Incorporated, an independent design and illustration production organization.

"Most industrial illustration is done by houses that do industrial products. The process only needs visualization up to the point where everybody can see what the design team is getting at and someone says: 'Yes, we'll do that for model year '86.' Then they usually go on to make full-scale models. I'm used by houses mainly to offer a finished alternative to what their design staff is doing. And for that they need a photographic rendering, which is a cheap way of not doing a model. What I produce is a three-dimensional solution shown in a two-dimensional way, but very realistic."

Mead's interest in the possibilities of the future was stimulated as a child by encyclopaedias, World War II fighter airplanes and the spectacular scenery of National Parks. "I remember doing a very elaborately illustrated story while in junior high school of an exotic laboratory on a mountaintop with a rocket being secretly built in a chasm. The illustration, drawn in Prismacolor pencil, showed a very streamlined 1950s Buick rocket, bright red, with lots of chrome. This was long before the space programme had started, and long before I consciously knew anything about rockets."

Was he aware of anything which gave him this image? "Somebody bought me a book called *The Conquest of Space* by Chesley Bonestell, which was a series of illustrations showing planetary views and so forth. Chesley Bonestell has long been considered the dean of space painting. He was the first one to do really detailed views of the Moon, Venus and all the other planets — he was a pioneer among astronomical artists. I started becoming really fascinated with space. This was in the late 1940s and early 1950s. All my rockets then were very automotive in shape."

Since those days, however, Mead's work has been

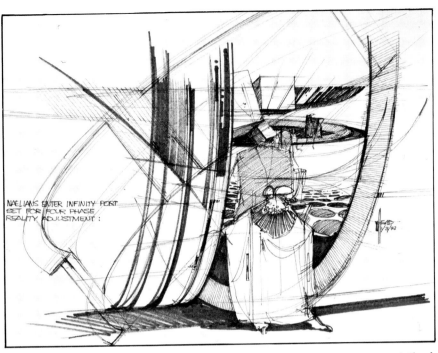

NAELIANS ENTER INFINITY PORT
SET FOR FOUR PHASE
REALITY ADJUSTMENT :

Pencil Sketch

characterized by the credibility and realism of his vehicles and landscapes. At the Art Center he learned how materials are manufactured and used, while his work for Ford and US Steel gave him further understanding of the industrial processes involved in making a complicated article. Later, he worked with architects and got to know why buildings look as they do now. "It's a combination of linear-produced materials — beams, sheets, glass, and so on."

Understanding present-day processes allows him to extrapolate. "You can logically make a change and still make it look believable. That's how I invent the real look to the future cars, buildings and so on. But I don't just use simple linear progression — I also throw in an assumed breakthrough of some sort which adds a certain weirdness to the future concept while continuing to make it recognizable."

Mead sees himself as an industrial designer first and an illustrator second. "All my work is straight commercial commissions, whether it's design work or illustrations. I don't have time to do hobby work at all." But every job allows him to put forward his particular perspective on the future, within the constraints of the brief.

How is a brief put together? "It usually starts with a telephone call, followed by correspondence saying what the client wants me to do. If we agree to go ahead, I'll do some preliminary sketches. If it's a new concept rather than a development of an earlier idea of mine, I usually spend some time doing preliminary

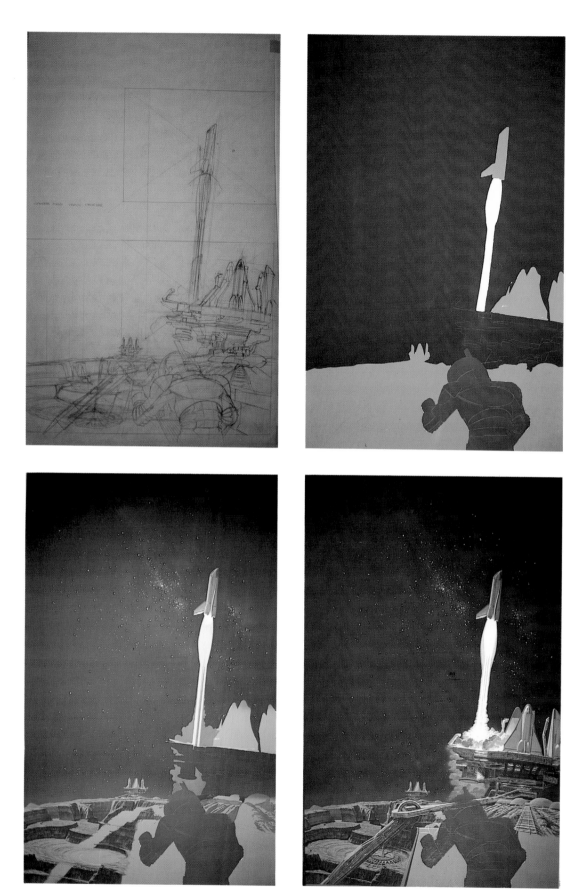

Stages in Painting

Shuttle launch from an asteroid commissioned by Greg Phillips Agency for AFROX.

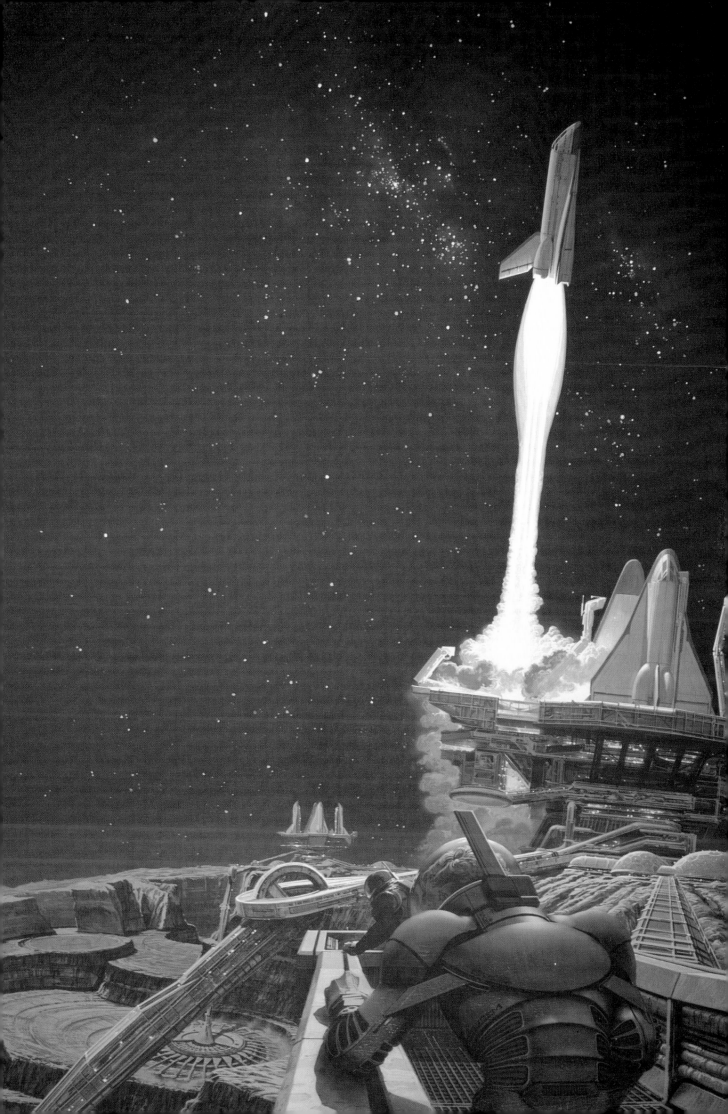

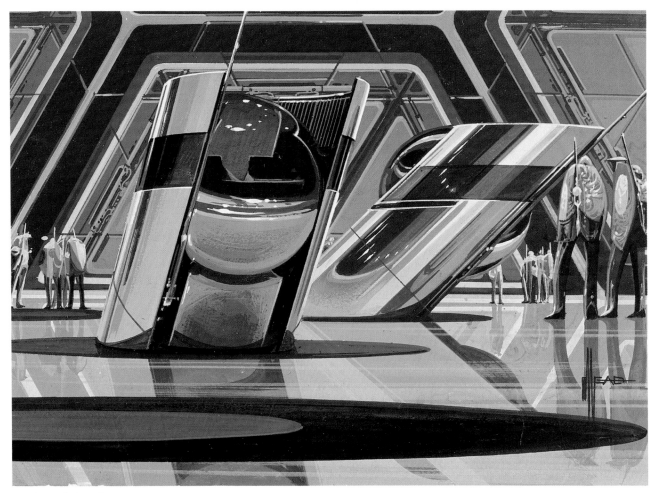

Gold Droid Guards.

sketches to familiarize myself with the design by drawing it from different angles. For example, I was asked to design a new kind of yacht, and I spent a week doing scribbled sketches on 8¼″ × 11″ sheets. Then I went to the actual boat-format drawings — profiles with the bridge, cabins and so on in proper size and perspective. Then I put an outer envelope over that."

The finished line-drawings are sent to the client as an in-progress update. The next stage is the colour illustration itself. This usually takes 3 to 4 days to produce. "In my mind the illustration is simply one particular shot of the object from the best angle. I usually have to solve the three-dimensional problems before I can make an illustration."

For the colour scheme he uses a file of magazine clippings, keyed to different subjects such as cars, planes, landscapes, views of the Earth from space, and even advertisements for products such as jewellery or champagne. He prefers to create his own palette rather than stick to standard colours. "You have to for industrial art because you may need to retouch, airbrush, match back and forth. My training at the

Art Center in doing compositions taught me always to use a very definite warm/cool bias when I render objects. This means that if you photograph them in black-and-white the objects will show up as well as they do in colour. I always bear this in mind when doing colour illustrations."

Invariably Mead will have several commissions in progress at a given time. Once a palette has been mixed for a particular illustration, his assistant then starts filling out the base colours and, depending on the schedule, doing the broad-area airbrushing. He's had an assistant for the last four years, but always does the basic design and the finishing of an illustration himself. "I can't use an assistant for any of the processes except the repeatable." The assistant completes the colour block-in process and starts off the broad-area shading from light to dark, warm to cool. "At this point I take over and give the illustration its finished signature. It's similar to the process the Old Masters used — they had fifty assistants chipping rough figures out of blocks of marble, doing fresco mixing, and so on."

66

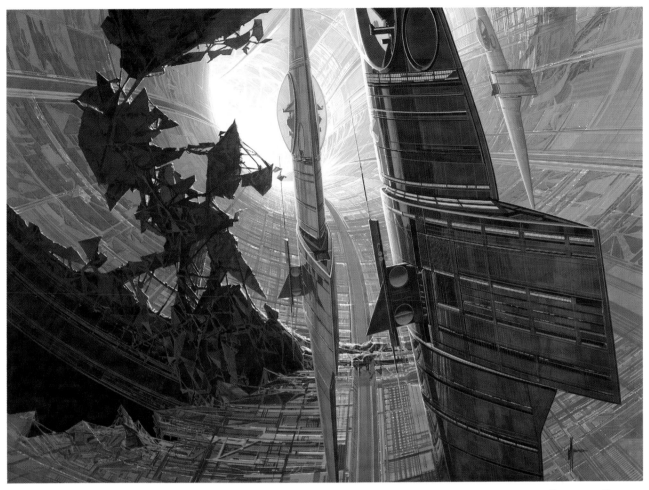

Disaster at Syntron.

Rough Sketch

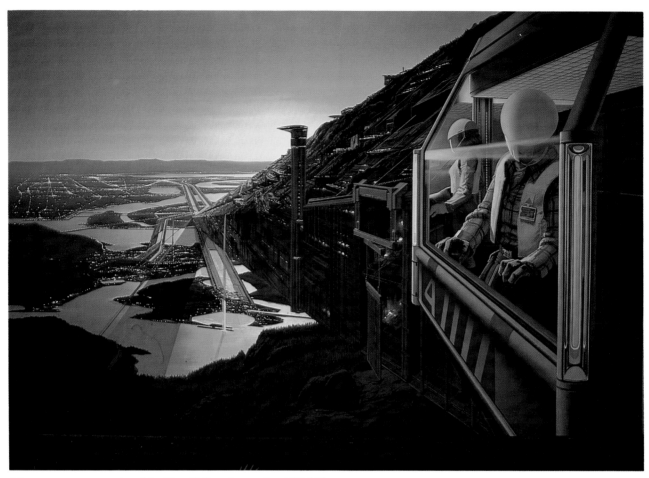

Megastructure commissioned by Greg Phillips Agency for AFROX.

Mead has only been using an airbrush for about three years. He relies on bottled gas for the pressure. "Compressors are too noisy, and the bearings wear out. Bottled gas is silent and easier since I can get cylinders delivered the same day. I use carbon dioxide rather than freon. Because CO_2 is dry, there are no problems with humidity and the airbrush doesn't spit. It's very annoying when you're trying to air-brush a small area of an illustration and the airbrush spits due to fluctuating pressure in the tube."

When putting the final touches to a painting, Mead uses both brush and airbrush. To get a fine edge with the airbrush he uses sheets of bond typewriter paper weighted down with a small triangle or something similar to hold them in place. He depends on brush edging to finish the hard edge of an illustration. "I only use an airbrush to duplicate the techniqueless illusion of a photograph. It's useful for putting down base colours and for getting that very soft progression of colour which you simply can't achieve any other way."

Mead's approach to the finished effect is as much pragmatic as artistic. "What I'm hired to do is to make a fake photograph. I'm not interested in the

nicety of the brush-stroke as a brush-stroke — that's painting. But with illustrations you can do visual combinations which would be difficult to achieve by photography with elaborate montaging, double ex-posure and such like." Illustrations also, of course, bear the individual stamp of the artist himself. "My work apparently has a pictorial style which is recognizable and can't be passed off to anyone else."

Does he find his style or technique has changed over the years? "Not really. Sometimes I worry about that. But you're always competing with your own product — with your last best idea." And the execu-tion of the idea is just as important as the inspiration behind it. "The idea may be excellent, but if the technique doesn't illustrate it properly, the client can be disappointed."

In recent years Mead has done film set and film hard-ware design for a number of major SF movies. He designed the interiors and exteriors of the "Voyager Entity" in *Star Trek: The Motion Picture* (1979), and in *Blade Runner* (1980) he not only designed vehicles for all five major characters but also did street scenes and interior views of apartments and laboratories. *Tron* (1981) followed next, and here Mead designed

Stages in Painting

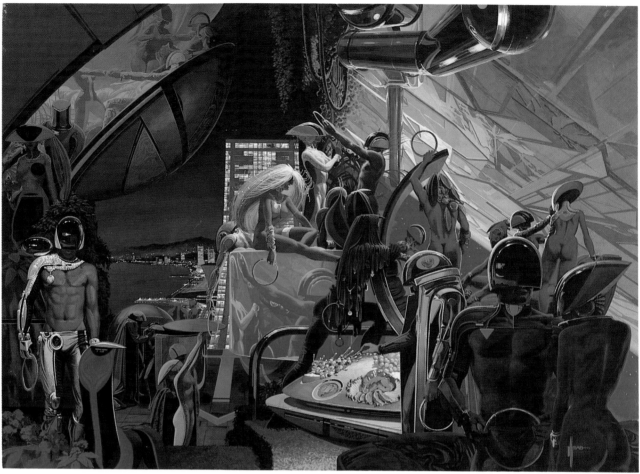

Party 2000

the logo itself, plus various vehicles and sets including the motorcycles, the tank aircraft carrier, the MCP tower, and much else. And in the forthcoming 2010 he is responsible for the "Leonov" spaceship, the EVA pod, various interior designs for the ship, and the first release poster art.

Prestigious though such film work is, Mead doesn't intend it to become the major part of his business, simply because he feels it's important to be diversified. "I would not allow my gross income for the corporation to exceed a third from any one source." This policy stood him in good stead during the last recession, when his business did not slow down but actually doubled.

Among Mead's more recent projects was a remarkable enterprise which involved designing six square blocks of totally blank ground in a major urban centre. The idea was to invent an ultra-modern version of the ancient bazaar marketplace. Mead designed a stadium which rotated once every twenty-four hours, following the sun, and he arranged building blocks around a platform so that the geometries of streets could be continually changed. The emphasis was on public interaction, with pedestrians being

able to adjust sluice-gates and thus alter the water-flows within the overall structure.

Looking further into the future, Mead has done studies of possible contact with alien civilizations, and he's also designed space habitats which would contain artificial environments in giant rings. Gravity would be generated by the rotation of the ring, and power would be derived from nuclear and solar energy. "There are things you can do in a controlled large environment in space that you can't do on a large planetary mass such as Earth. Space exploration offers the potential of mining asteroids of precious elements, of skimming gases off the atmospheres of other planets, and much else."

This image of the future is an energy-intensive one, but for Mead this is no stumbling-block. "Unlimited energy is not so difficult to realize once you get beyond the burning of fossilized petrochemicals — that's a primitive way of doing it. We're not so much advanced from the people who burnt oil in a lamp in Babylonian times. Nuclear fusion offers a lot of potential as a future energy source; it's cleaner and more controllable than the fission processes which we're currently using. And because fusion is an artificial

70

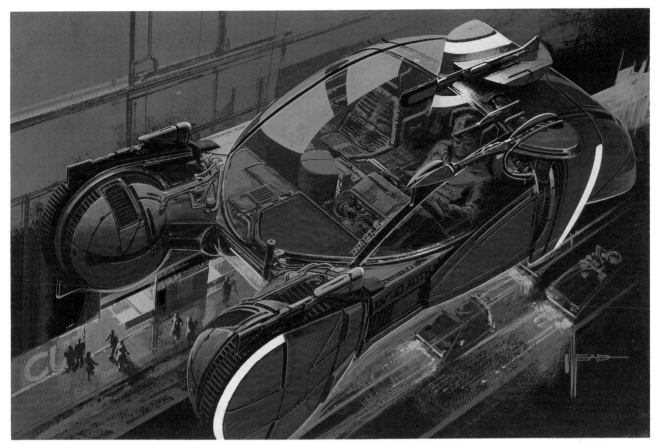

The Spinner, a Police vehicle for the movie Blade Runner.

process, it can be stopped immediately if necessary."

Mead works in a busy office, and he likes to get each job done as quickly as possible so that he can get on to the next one. Because he enjoys his work, he finds no need for any particular kind of recreation. "For me, pressure is not being allowed by a client to fulfill the logical extension of what I've been hired to do. Or not being able to explore all the niceties of the situation because of deadline demands. That's very frustrating." Mead's philosophy influences everything he designs, and his work is an affirmation of continuing human progress, a means of pointing the way to the future by exploring the limits of the possible.

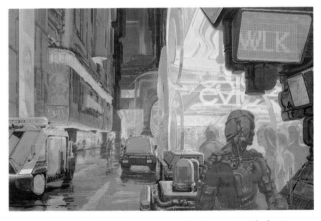

Colour sketch of a street scene for the movie Blade Runner.

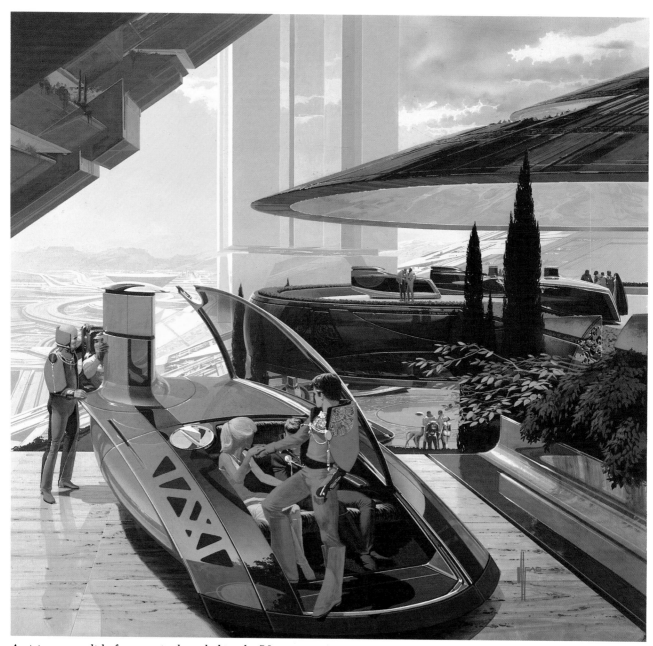

Arriving guests alight from an aircab overlooking the (Norcon Centre) surface transport inter change. Private gondallas glide around two arrival decks on the trans-lobby levels. Leased condominiums at upper left house both private and corporate groups, while the Mega-Rise in the middle ground holds scores of national, and international offices.

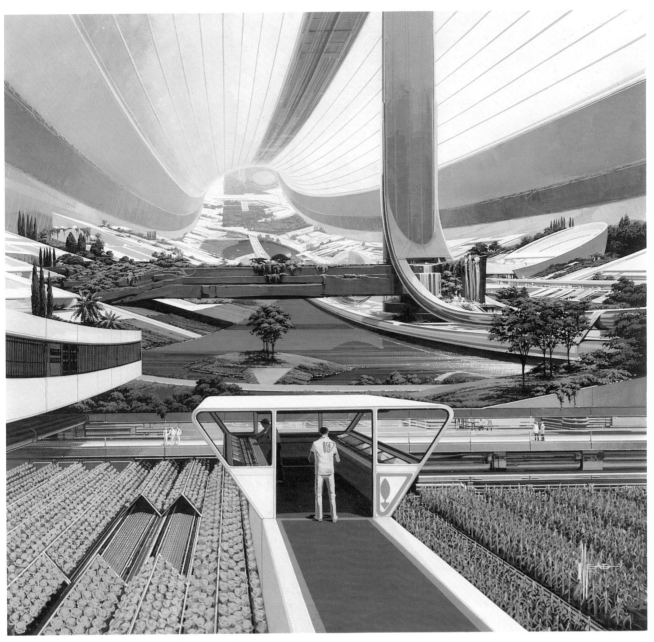

Space Station Interior for National Geographic Magazine

Chris Foss

A reporter once asked Chris Foss where he got his spaceship images from, and he replied that he took photographs of them whenever they flew overhead. He's an affable and unselfconscious man who hasn't let success go to his head. The influence of his artwork can be measured by the number of illustrators who have studiously imitated his style.

Chris Foss's name is synonymous with massive artifacts framed in dramatic airbrushed skies, though he's at pains to point out that he's always dealt in other images apart from spaceships and futuristic architecture. Submarines, sailing craft, warships, tanks and aeroplanes have all featured in his illustrations; he also did the figure drawings for *The Joy of Sex* and *More Joy of Sex*. But it's his science-fiction paintings which are best known.

A sense of immensity is what Foss's artwork most immediately conveys. The majority of his paintings feature expanses of sky or space in which huge starships and monolithic buildings stand out with great clarity. At first glance they seem to be pure expressions of the grandeur of scale in which biological life is incidental, with humans or aliens being sealed inside their starships and cities, and animal and vegetable life being reduced to insignificance by sweeping vistas. Yet on closer inspection, his striped and chequered spacecraft often resemble insects or tropical fish; they are the embodiments of an awesome technology but also the products of a playful and very human imagination.

Foss's artifacts are always complex, with a weathered, often battered look. It's perhaps this aspect of his work above all else that made him an original and which has been copied by others. Nowadays we accept that the future will look as dirty and beaten-up as today, but it was Foss who first gave us a hint of this. From the start, he always paid great attention to making his artifacts look used. "The funny thing is, it comes from the railways. When I was young all the trains were very dirty and scruffy. I always liked that."

In fact, trains occupy a central position in Foss's life. Born in 1946, he originally hails from Devon and spent his early years exploring the old railway tracks in the area. He built models of steam engines from soldered scrap metal. Encouraged by his art teacher at school, he also began doing pencil sketches of the countryside and of run-down shipyards and harbours. He combined car parts from old wrecks into custom-built machines of his own design and colour schemes. Visiting Guernsey in the Channel Islands, he did pen and ink drawings of the concrete towers and gun emplacements built by the Nazis during World War II. "I still remember some of the subjects I worked on for hours, getting them absolutely right, the way they were."

Foss's ambition had always been to be an artist, but under family pressure he went to Cambridge University to study architecture instead. This was in 1964. Two years later he dropped out, disillusioned by his course, and went to work with an architectural sculptor, doing drawings for mould assemblies and plans for the details of new buildings. Meanwhile he continued to produce artwork, selling it wherever he

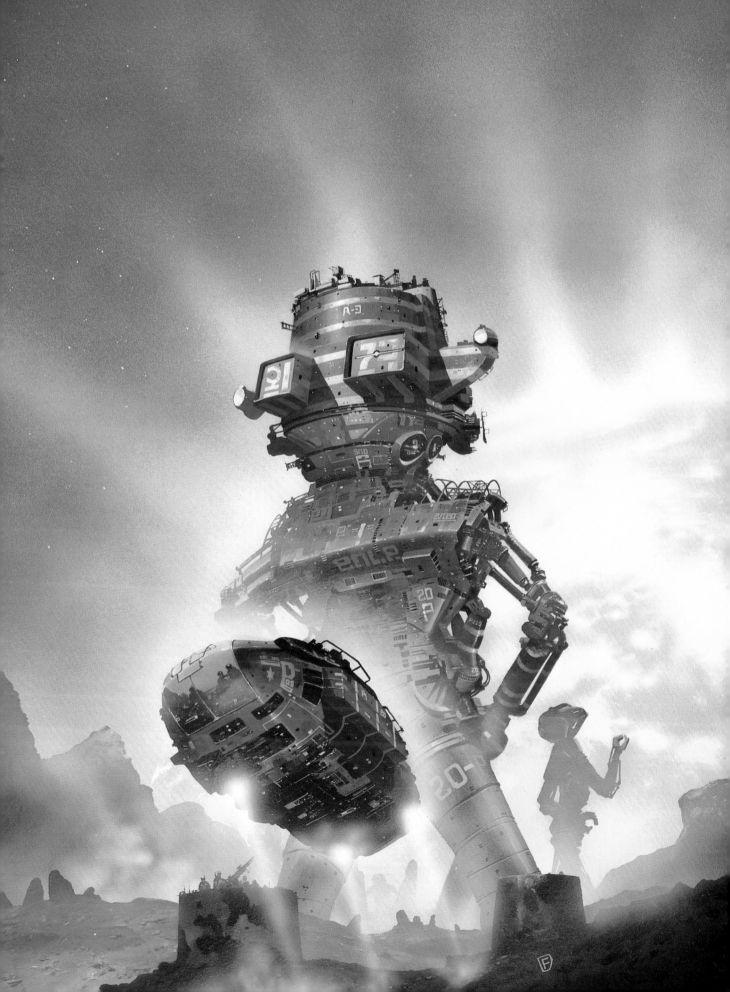

was able and gradually improving his technique.

In 1968, he left his job and supported himself and his wife by driving hire-cars. That same year he bought an airbrush. Two difficult years followed while he struggled to make a living from his art. Finally he received a cover commission from a hardback company which led to him being taken on by an artist's agency who were vigorous in promoting their clients.

This was in the second half of 1969, and since then Foss hasn't looked back. At first he produced covers for all sorts of books, though later he began to concentrate on scenes of warfare ranging from El Alamein to the far future. His World War II paintings include some of his best work, but it was his science fiction covers that captured the public's imagination and made him a household name among SF fans and authors alike. In more recent years he has done conceptual designs for the films *Superman, Alien* and the forthcoming *Dune* while still continuing a steady output of book-cover illustrations.

Foss has a studio in London and homes in Dorset and France. His studio looks out over the rooftops of

Studio

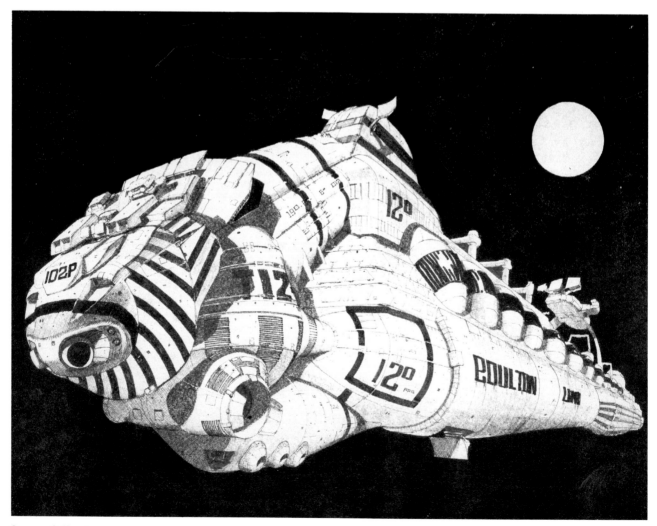
Spacecraft Sketch

76

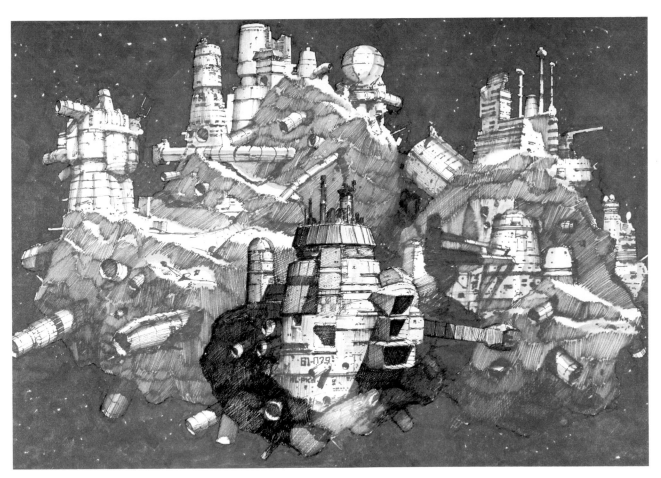

Pencil Drawing

Fulham and it's a tidy place, with a wide range of artists' materials neatly stacked away in a large number of small metal drawers. Yet he sees himself as unmethodical — especially with his time.

Despite this, Foss has a good reputation for reliability. "I'm very good on time, the reason being that I don't take on much work these days." It helps that he's a fast worker who once painted a cover in a single day. Usually a painting takes him about three weeks, "but it can often take two months, just due to mucking about. It's a constant battle to get enough done." He never works on weekends but instead escapes to Dorset, where he is able to indulge his passion for trains. He's currently building a narrow-gauge railway. "What I do for fun is actually far more interesting than painting. Building the railway really is my consuming interest at the moment. I adore it — it's a world I can lose myself in completely."

Paradoxically, trains seldom feature in his actual paintings. "They're more fun in real life. They're tactile." But though he describes painting as a chore, he nonetheless speaks enthusiastically about the current book project which he is completing for a French publisher. "It's basically a heavily illustrated diary of a girl in the future who goes through all sorts of rather strange adventures. Half the illustrations are in colour, half in black and white. The colour is all large detail paintings and the black and white is pencil drawings done by the girl on the spot as someone would draw for an illustrated diary. It's a fairly erotic book which will marry the style of drawings in *The Joy of Sex* with my science fiction stuff.

"I've had quite a change of direction recently — I no longer just do what I call science fiction wham-a-bam paintings. The days of the spaceship hanging in the sky with the airbrushed background for me are more or less gone. I think my paintings are becoming more narrative. They're still realistic, but people are being introduced more and more. The hardware's beginning to take second place. I see flesh as complementary to machinery." How does he get started on a piece of artwork? "Where the idea comes from, I haven't the faintest clue. It just sort of turns up. I've never had to thrash around. A terrifically fertile source of ideas is doodles done while I'm on the telephone. With long phonecalls I invariably doodle on a bit of paper, and quite often in these is the germ of a nice idea. I also find travelling a fertile area. I don't have a radio in my car, and I adore aeroplane trips. I never bother buying newspapers or magazines when I'm travelling — I just stare out of the window."

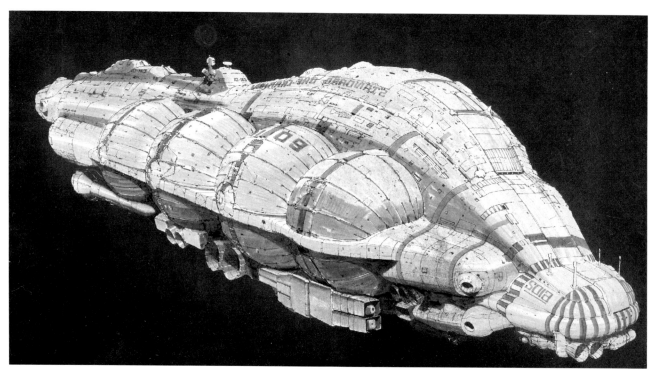

Spacecraft Sketch

Sometimes he'll start a painting with a space-sky, but most begin with some sort of sketch. He uses ordinary pencils, but prefers a pencil mechanical pen since it doesn't need sharpening. "I draw on very fine paper which I've prepared. I don't want to say too much about that — it's one of the ways I get a very black line which you can't normally get with a pencil." The experience of having had his style extensively copied has left him wary of revealing a lot about his methods.

"The final painting never bears any relation to the rough art at all. Things just happen — I get a better idea or there's an accident on the board and I suddenly realize that something else will actually work much better. All sorts of things can happen. I would say that ninety percent of the paintings are improvisation."

Sources of the imagery that appear in a painting can sometimes be pinpointed. Foss enjoys watching natural history television programmes such as *The Living Planet,* and a strange lizard or exotic fish might reappear transformed in one of his paintings. He doesn't collect any reference materials, though he has used photographs on specialized jobs such as advertising posters requiring an illustration of a specific product. Similarly with *The Joy of Sex:* "That was a very cut-and-dried thing, illustrating specific human situations. Because I had to do about 130 drawings in two months, photographic reference was essential."

Does he use reference materials for his space illustrations? "Absolutely none whatsoever except occasionally for figures. Most of the things I do you can't get reference materials for. One thing I would say — from the age of ten onwards I drew everthing that was around me. I can't help feeling I'm still feeding on that."

The initial sketch is drawn out full-size on a 3′ ×2′6″ board. For a while Foss used assistants who would

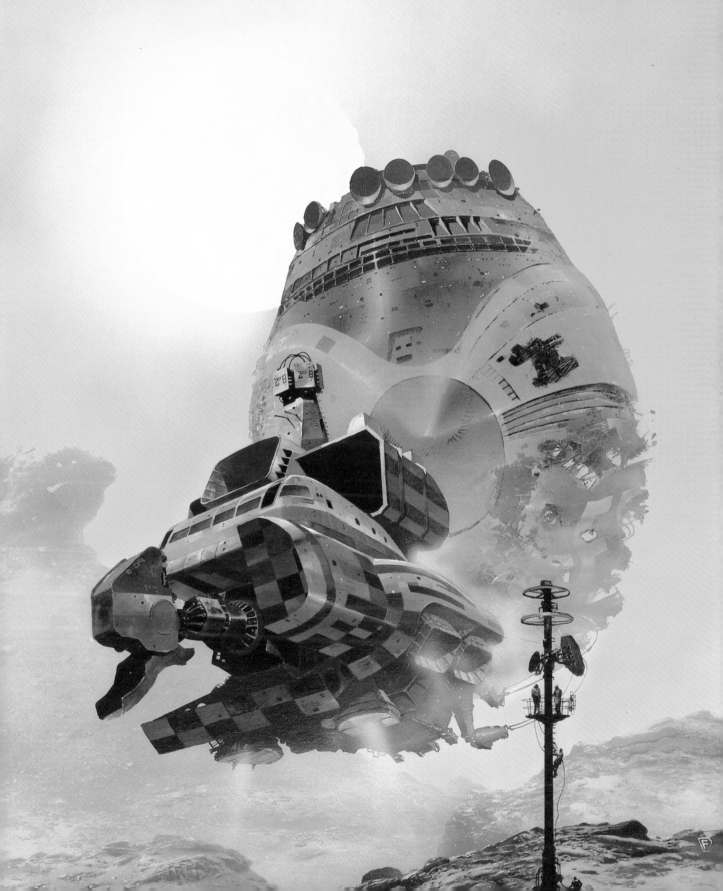

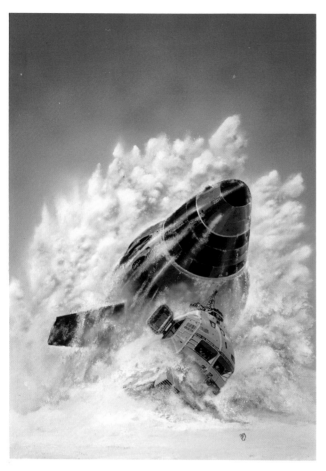

Demon 4

mix up the paint and fill in the simple blocks of colour before he brought the painting to life by doing the fine detail work. "I actually thought that it would be a good way to get more work done, but really it was almost as if they interfered. I'd spend a lot of time going over what they'd done, so it negated their use. I haven't used assistants for over a year now. These days I'm far more positive — I know exactly what I want to do, as and when I get around to doing it.

"I paint in acrylic paint, normally on an illustration board. I use whatever board I can lay my hands on as long as it's sound. I invariably use British materials and I always take them with me to France. American materials are on a par with British, though they're usually dramatically cheaper. The only brushes I use are Windsor & Newton Series 7."

He also uses acrylic with his airbrushes, but it does cause problems because it dries quickly in air. "It's actually the most hostile material you can use with an airbrush." In fact, he uses the airbrush less and less in his paintings these days. "I never, ever mask. It takes too much time and it gives too hard an edge. The major implement I use is actually a paintbrush." How does he put on big areas of colour? "With a big paintbrush."

Foss finds the quick-drying of acrylic an asset, and he bears this property in mind while working. He occasionally uses other mediums. "Ink of various sorts. If it stays on the board, you sometimes get some nice effects. I love experimenting with new materials. If I see something in a shop that I didn't know about, I usually buy it out of curiosity, though I tend to stick with the materials I've found that work best." As soon as a painting is complete, he throws everything else away, only keeping drawings if the linework happens to appeal to him.

Does he use any special techniques, such as montaging? "I've never done montages because I always like the picture to look uniform — skilled enough so that people aren't quite sure how it was done." On book jacket commissions he aims for a sharp, dramatic cover which alludes to the book without being specific.

He cites as his early influences Picasso and Turner. "I really liked Picasso's linework and his blue period. Another artist, whom I found very erotic, was Egon Schiele. I came across a book of his at school. He did these strange, tortured line-drawings of women which I though were phenomenally effective."

The Family D'Alibert

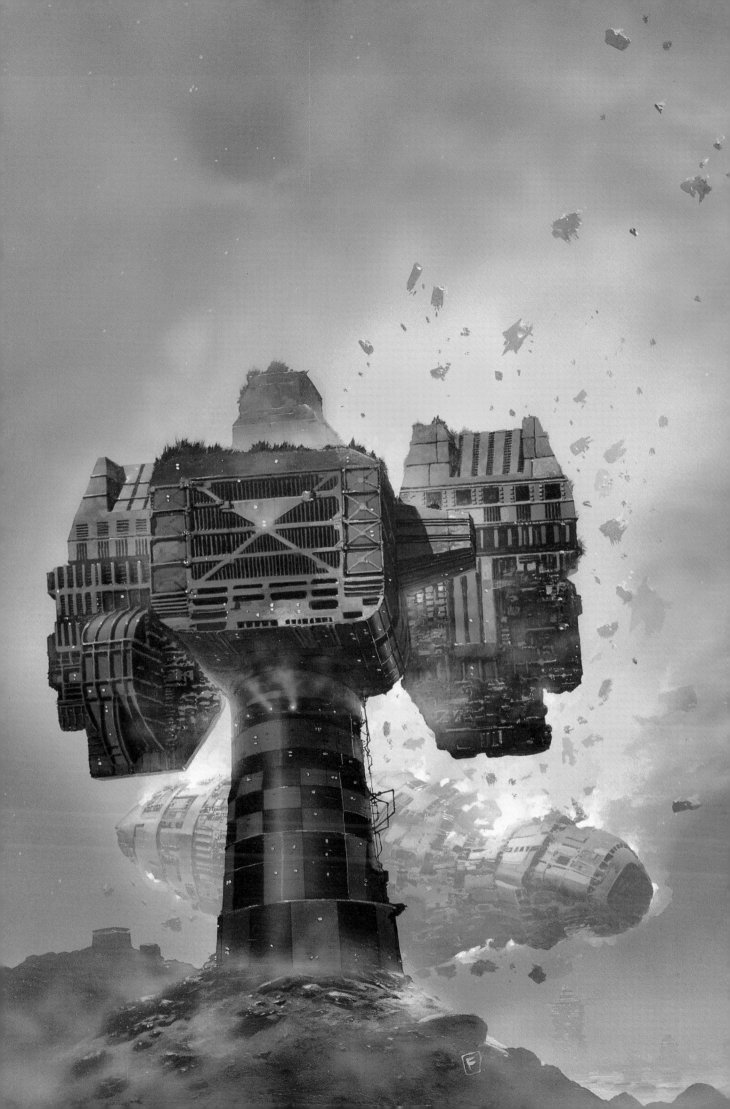

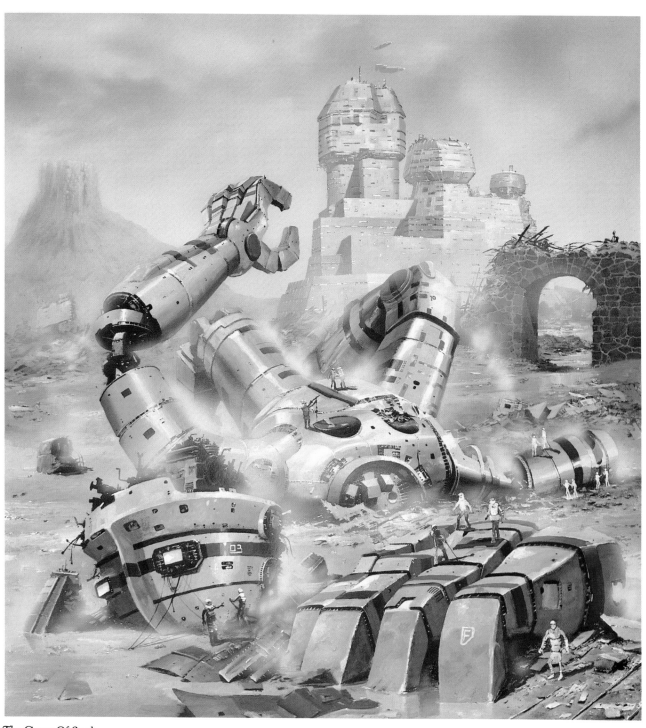

The Caves Of Steel

The Dawn Of The Robots

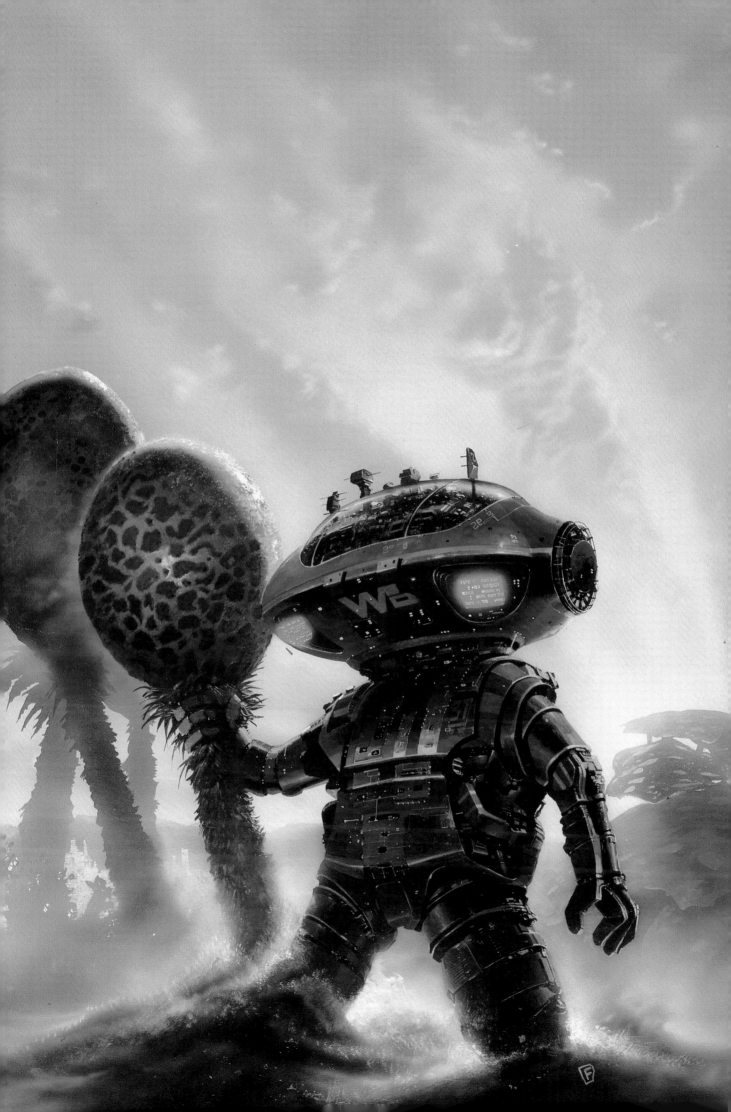

Martin Bower

A list of objects which includes crab claws, radio valves, yoghurt pots and washing-up liquid bottles seems about as miscellaneous as its possible to get. Yet these are all items which Martin Bower has used in his model-making. He scavenged garbage dumps for the innards of television sets, salvaging anything that looked interesting from a design point of view; and in his hands these discarded pieces and products of today's technology were transformed into tomorrow's hardware — weapons, vehicles, spacecraft and futuristic architecture. As a model-maker, Bower has worked on such TV shows as *Space: 1999, Blake's Seven, Doctor Who* and *Tripods;* he has also contributed designs for the feature films *Alien, Flash Gordon* and *Outland.*

Bower lives and works in a cottage with outbuildings in the Purbeck Hills of Dorset on the south coast of England. Born in London in 1952, he was an avid fan of the British comic *Eagle* as a child, and he followed the Space Race with a keen interest. He left school at 17, and worked as a scenery builder for a private TV company before frustration drove him to seek out the addresses of model-makers. By then he had a portfolio containing over a hundred colour prints of his SF models, mostly space hardware.

He was hired on the spot by Scale Models International in 1969, and worked with a team making models for a variety of customers including P&O Lines, Hawker-Siddley Aviation and the RAF Museum at Hendon. At Scale he learned the technicalities of working with different woods and also acquired the engineering skills to work in brass

and plastics and to spray cellulose paint like an expert. However he was always required to work closely to a given plan.

He left Scale in 1972, hoping to find a more creative outlet for his imagination. He contacted dozens of commercial and film companies, but had no luck and was forced to eke out a living as a casual house painter. In his spare time he continued to work on space models, combining his wood-working experience with the inventive use of modern bric-a-brac.

"For example, if I wanted to make a model of a satellite, I'd use an interior of a radio valve. I'd find a metal mesh plate inside and I'd cut that out and solder it onto a piece of wire to make it into an aerial. I just found that all those pieces looked so technical." He also began to make his own components and to cannibalize parts from plastic construction kits to improve his design effects.

In 1974 he joined the production team of the TV science fiction series *Space: 1999.* The special effects director was impressed by his private work of the past year, and one of his existing models became a battlecrusier which appeared in five programmes. He was commissioned to produce models for the rest of the series, and he built 54 in all, featuring rockets, vehicles and space habitats.

"Working on *Space: 1999* taught me to be more professional. I had two weeks between episodes to produce a job, and the most valuable lesson I learned was how to pace myself. Having less time actually helped

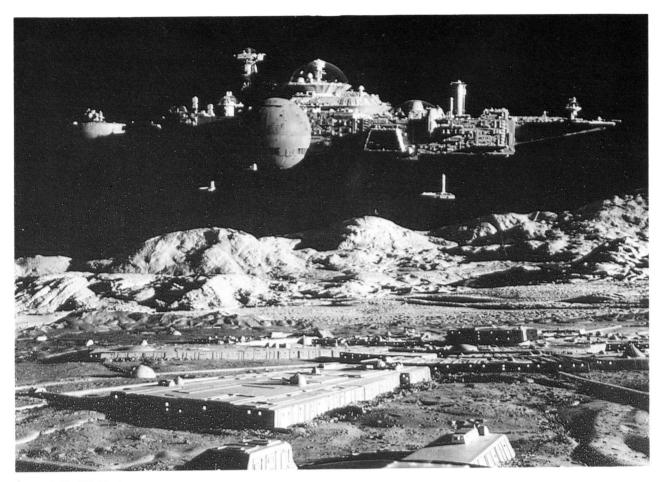

Space 1999 S.S. Daria

Space 1999 Battle Cruiser

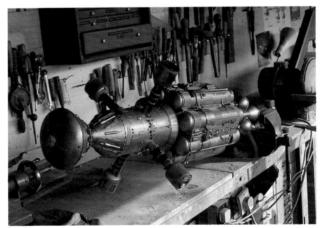

Space 1999 Space Station

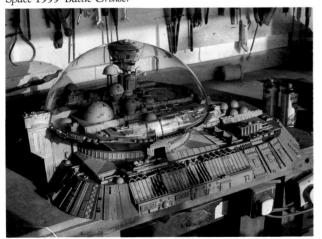

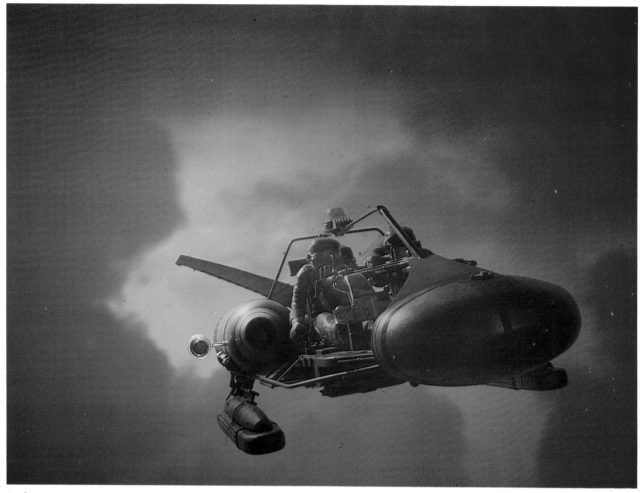

Iceskimmer

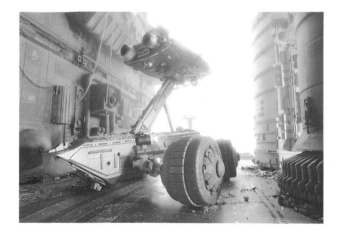

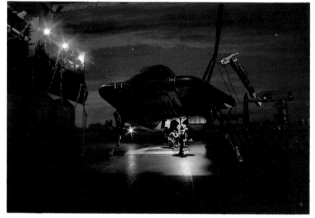

Gunship

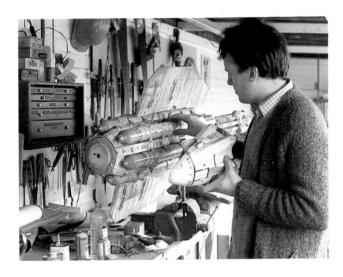

improve my technique — it made me more efficient and productive."

Bower worked for three years on *Space: 1999*. During this time he also designed the main spaceship, "Altares", for a BBC TV film "*Into Infinity*". Here he had total control of the model-making, doing the design work and as with *Space: 1999*, building everything in his own studio. In 1977 he became involved with the film *Alien,* working as supervising model maker, heading a team of model-makers. "Ridley Scott, the director, was really responsible for the entire look of the film. He wanted this very intricate, detailed appearance, with everything looking extremely dirty.

Bower built the towers of a refinery and he also helped contribute to the design of the "Nostromo" — the ship which tows the refinery before detaching and going down to the planet. "That was built like a giant wooden box, and we stuck panel-lines and lots of accessories all over it to make it look realistic. Ninety per cent of the models on *Alien* were scavenged model-kit parts — we used literally thousands of them, ordering in bulk from a model shop. But we made sure that the kits did what we wanted. For anyone starting out as a modeller, it's no good thinking that you can just buy a few kits and throw all the parts together, You've got to be selective."

Bower's advice to potential model-makers is to work in three dimensions as soon as possible. Always be prepared to change the design and strive to make it look good: accuracy is less important than effect. "It's the dirtying-down process that gives a model its look of authenticity. And the panel-lines. I'm always studying aircraft for the dirt-flecks on the wings behind the rivets.

"When I was starting out I'd paint a yoghurt pot silver, but it still looked like a yoghurt pot. So I'd use an ordinary black ballpoint pen to draw in a panel line, then I'd shade it with a pencil. Straight away it would start to look like it's flown through the air. If you view the Space Shuttle from a distance, it looks a smooth, clean shape. But when you get up close you see all the lines on its hull. Then you look at the underside and it's black and covered with streaks of all colours after re-entering the Earth's atmopshere.

"I don't use high gloss on models because that makes it difficult to put in the panel lines. I use a spray gun with a lot of air in it to keep it dry. This gives me a silk finish. If I'm using a can, I hold it at a distance. I dust it on very lightly. I draw the panels in with black ballpoint pen and scrape the paint off others with a scalpel to give a 'clean' look on some panels as with real aircraft, where panels are always being swapped around or replaced after repair. I cover the clean panels with tape, then smother the model in dry powder paint. The powder paint is then rubbed off, but it catches in the lines. I remove the tape and put a clear coat over it to seal it on."

He uses different colours for the dirtying effects — rust being a particular favourite. And he bears in mind the function of a model when putting in streakmarks; the dirtying-down process for a spaceship will be different from that of a building. He tries to express the essence of an object — those parts of the image that make the image itself. Spaceships suggest a sense of mass, bulk and lots of surface detail. "But the details have to be in the right place. It's no good sticking pipes everywhere — it's got to look as if it performs its function."

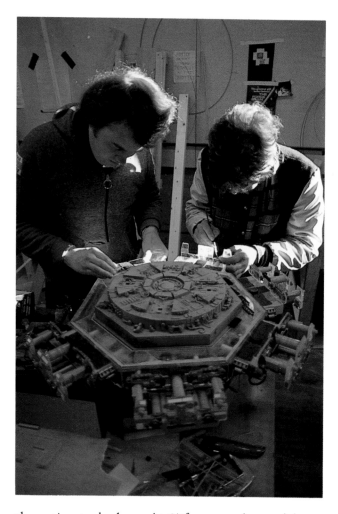

Among the early influences on Bower's imagination were the fantasy film creatures of Ray Harryhausen and the hardware in the 1950s SF movies such as *Forbidden Planet* (which featured Robbie the Robot), George Pal's *The War of the Worlds* (with the Martian war machines) and *This Island Earth*. How does he create the designs for his spacecraft and hardware? "A hundred and one things give me inspiration. I don't keep a file of illustrations and I've never gone to a book. All I can say is that I've got a very visual mind. Just looking at things such as aircraft or even the fittings on vacuum cleaners will give me ideas. When I'm thinking about a spaceship or a piece of hardware that I'm going to design I can actually have an almost photographic mental image of it."

After *Alien,* Bower worked on *Flash Gordon* in 1978 and 1979, again designing various spacecraft. In this case the film-makers wanted ships which had a clean, period look, in contrast to Bower's preference for dirtied hardware. he also made a plasticine model of a little creature that lived in a tree-stump on one of the planets.

Next came *Outland* (1980), and for this film Bower and colleague Bill Pearson built the refinery where the action took place. At 27ft across the model was the largest he's worked on so far, and it was built in six sections which were assembled at the studio. Brass-etching was used for the surface detail. This involves drawing the required design which is then photographed and printed onto very thin sheets of brass in an acid-resistant ink. The sheets are then dipped in acid and the metal erodes, leaving the design filigree work which can be glued to the model. The process is repeatable so that panels can be produced in bulk.

Bower also used vacuum-forming on the models, a cheap and efficient method for producing bubbly-type shapes. It entails heating and then blowing a sheet of plastic before sucking it back into a mould. On a kitchen-table scale, this process can be duplicated by very carefully heating the plastic sheet in hot oil and draping it over a mould; tiny pinholes are made in the pattern and the air sucked out of the mould with a vacuum cleaner.

In *Outland* Bower also detailed the shuttle which lands towards the end of the film. "We used a steel framework covered in thick perspex plates. Onto this we put brass working parts, a few kit-bits and four

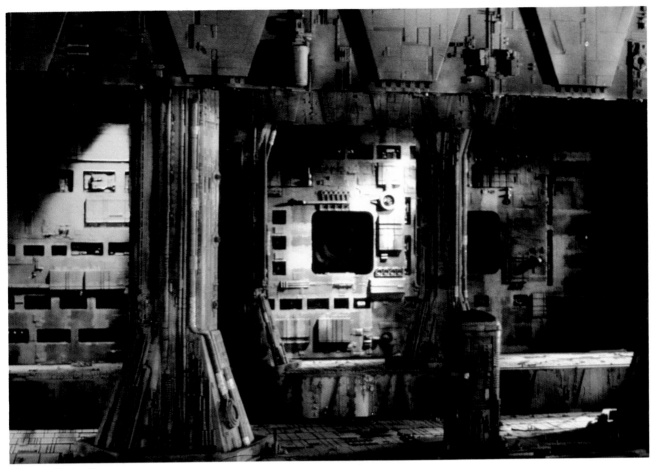

Alien — Engine Room

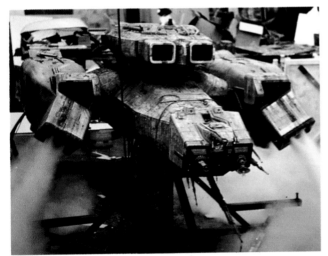

Alien — Space Vehicle

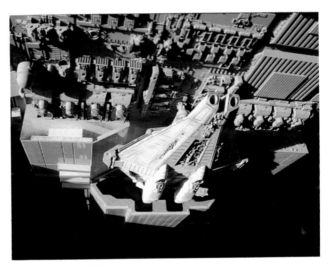

Alien — Escape Vehicle

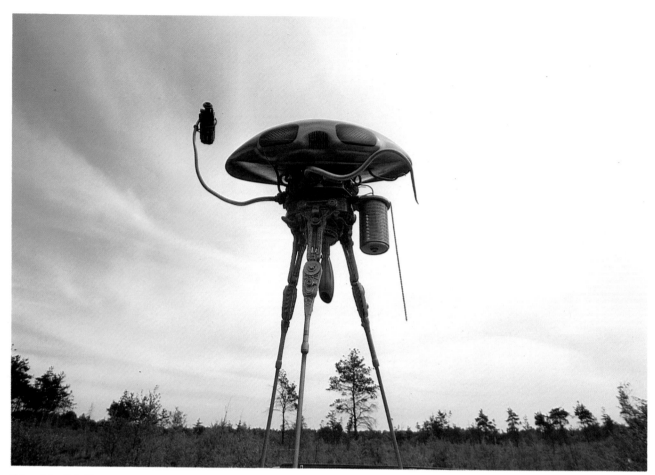

War of the Worlds

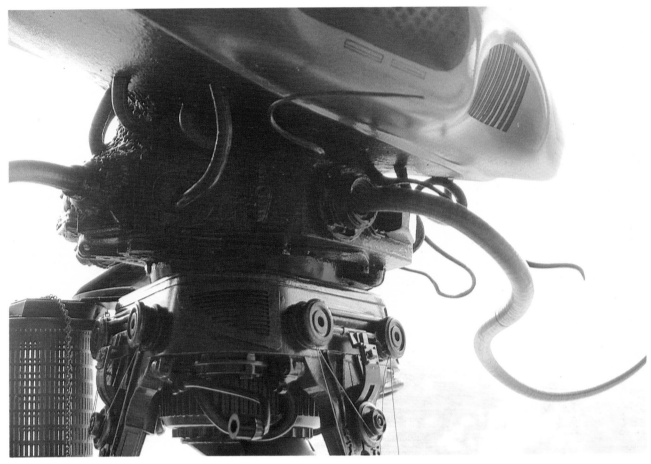

War of the Worlds

enormous functioning hydraulic legs made of steel. The landing was shot in high speed, the model being dropped so that it bounced on its legs. Then the film was slowed down and cut as it hit the ground. The model was only 3ft long but it weighed 45lbs."

Does he see fashions in film hardware changing? "I think it's tending back towards smooth surfaces — the SF images of the 1950s. When I did some alien spaceships for *Space: 1999* I went back to the imagery of *Forbidden Planet* — not details except rivets and panel-lines. But I kept the weathered effects on them."

Film-work invariably involves being part of a team and having designs vetted by the art department. But Bower also does his own modelling purely for the fun of it, or for private individuals on commission. For an *Eagle* enthusiast he's made models of various spacecraft from the "Dan Dare" series, and his own house is filled with figurines of fantasy creatures and female androids.

"People tend to think that because I've worked on things like *Alien* and *Space: 1999* I'm only interested in spaceships and futuristic hardware. But that isn't

true. I've always enjoyed Tolkien's *The Lord of the Rings,* so I made models of characters from the book such as Gandalf and Bilbo Baggins. I've also made a lot of android ladies."

He builds the models in one-third scale. "If you go any smaller than this, you can't use human hair — it just looks like a straw thatch. I use a child's hair for my models. They're made in plasticine and sometimes glass-fibre from latex rubber moulds. The eyes are ball-bearings painted in a lathe and glazed. They're the last thing that goes in — through a hatch in the back of the head." The flesh-tones are airbrushed with oil paint, and the uniform is a combination of things found and things scaled down. The costume may be stretch nylon, sewn around the model, the glasses cut from a plastic bottle-top, the weapons made from perspex.

Bower originally started model-making not as an end in itself but to create images on a photographic film. "When I was first starting out I didn't have anything like studio lights, and on one occasion I actually cut a hole in my parents' black curtains to let the daylight shine through and create the effect of a sun in the final

91

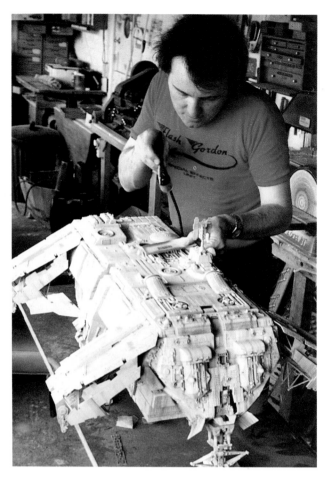

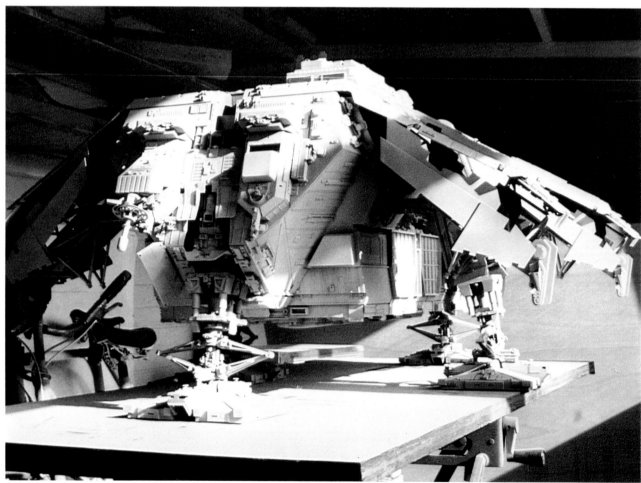

Outland — Spacecraft

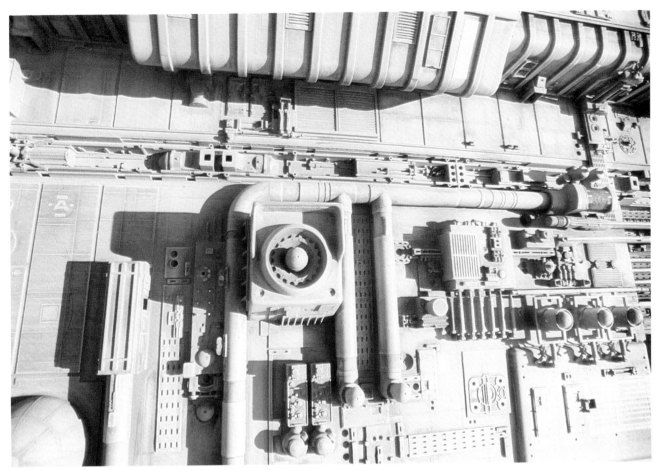

Outland — The Refinery

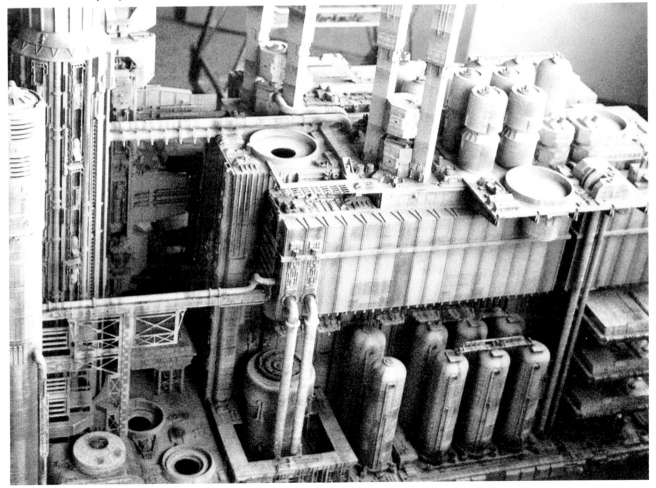

Outland — The Refinery

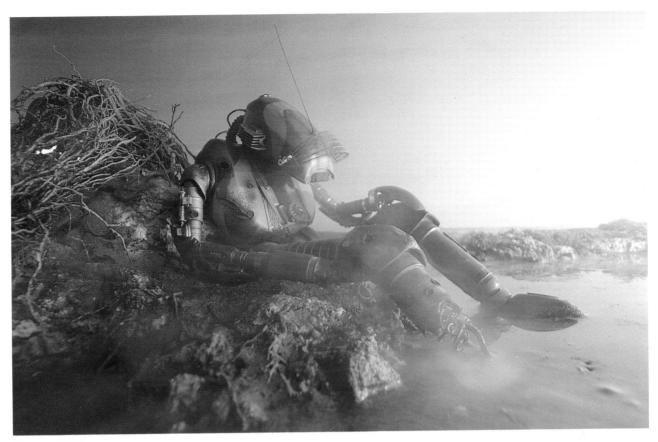

Universal Soldier

photograph, reflecting onto the landscape I'd built. The landscape itself consisted of Polyfilla mountains on a mirror to represent water. What I was interested in was creating a whole environment, not just a spaceship sitting on the suface." Later on, he discovered an effective method for producing interesting sky backgrounds by using a tank of clear water lit with coloured light into which he pumped condensed milk. This was then photographed with a neutral background onto a separate transparency which formed the "sky".

Bower has come a long way from his makeshift beginnings. The scale of his work is now light industrial rather than kitchen table-top, and his studio is fully equipped with bench power tools and compressors which complement the handtools of a dozen trades. His is a multi-medium art-form, and the models are built for strength and durability. He listens to music while working, and divides his life between the peaceful solitude of his countryside studio and hectic periods working in London film and television studios as part of a team. In his conversation he projects a great enthusiasm for his model-making which springs from his fascination with complex artifacts. "I never run out of ideas. I haven't got enough outlets for them! I've got boxes of drawings for spaceships I've never made."

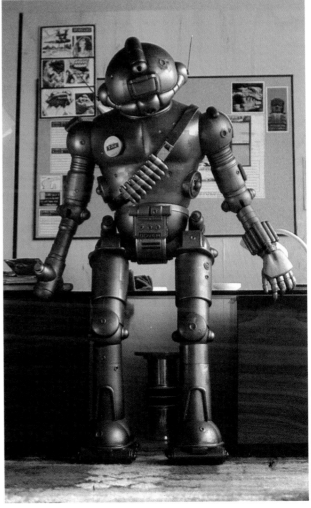

Robot

Boris Vallejo

As a break from painting, Boris Vallejo plays the violin. He's a busy man who since 1977 alone has produced well over 300 book jacket illustrations which include covers for such well-known series as *Tarzan, Doc Savage* and *Conan*. His fantasy paintings are notable for the grace and proportion of the human and non-human creatures which inhabit them; they are visions of ecstasy, enthrallment and transformation, depicting worlds which often have the dreamlike qualities of nightmares or secret longings fulfilled. In all of them there's a concern for the beauty of the naked human form — a beauty sometimes enhanced by wings and counterpointed with gnarled trees, the coils of snakes and the horns of demons.

Born in Lima, Peru, Vallejo now lives in New York with his wife, Doris. He works at an oak desk in a studio lined with bookcases containing coloured inks, linseed oil, turps and a wide range of reference books on natural history subjects. His cluttered desk holds drawing boards, Prismacolor pencils, magic markers and film processing equipment. The studio also contains a taped library which provides the background music — usually classical — which is always playing whenever Vallejo is painting.

As a child he always imagined that he would eventually become a doctor, though his fascination with art began at an early age. "When I was about 10 my father bought me a set of about fifty 8 × 10 inch prints of famous paintings, beautifully reproduced in full colour on fine-grain canvas-like paper. This was in Peru, though the paintings came from Spain. I treasured those prints. They were all Old Masters such

as Vermeer, Rembrandt, Van Gogh, Da Vinci and so on. I spent several years copying these paintings. My basic training in art was as a fine artist — I liked classical painters best. My favourites were two Spanish painters — Murillo and Velasquez. I considered their work to be the highest standard of painting."

Vallejo did drawings and drew murals on walls before beginning to take formal art lessons at the age of fourteen. However he did not think that he would ever make a living out of his illustrations, and he studied medicine at university. But he also continued with art lessons, and in the end decided not to pursue a medical career when he actually got a job for a short time doing instruction sheet diagrams. One of his friends was a talented artist himself, and Vallejo believes that he learned more from being coached by him than from formal classes at art school. The classes did, however, give him his first opportunity to draw nude models for several hours a day.

Eventually he began to take samples of his art to publishing houses, thinking that they were as good as anyone else's. He was surprised when they were turned down, but in retrospect feels that he displayed a common failing with beginners by not being objective enough about his work. He believes that the artist has to cultivate an awareness of his shortcomings before the can begin to improve and produce professional work. Good art teachers can help this process along, but it's also important to study one's own output critically and develop an

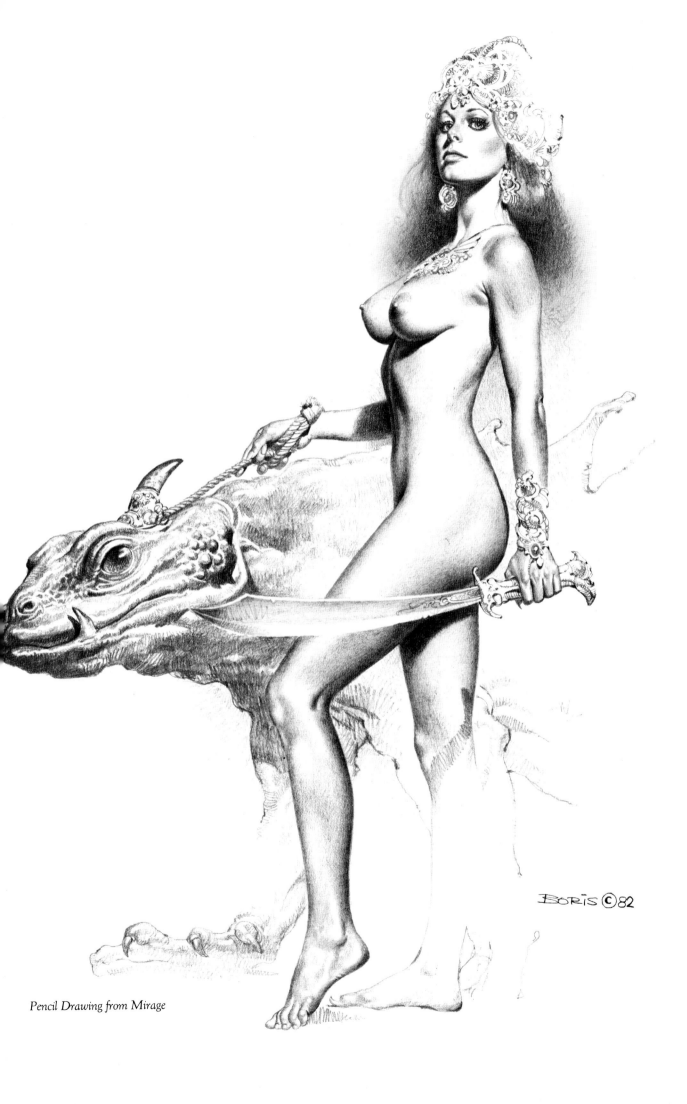

Pencil Drawing from Mirage

BORIS ©82

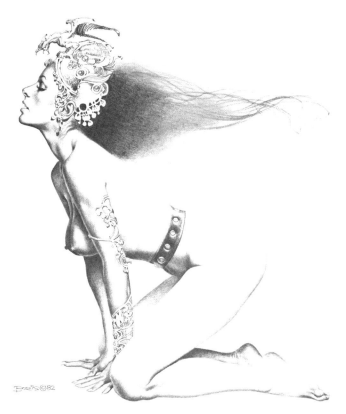

Pencil Drawing from Mirage

acute awareness of texture, highlights, shadows, contrast and the use of colour. Yet it's also very necessary not to appreciate your shortcomings *too* profoundly. "If you understood how far behind you are in comparison with, say, the Old Masters, it would be overwhelming."

Vallejo was fascinated by Rembrandt's use of light and colour, and he studied his paintings before experimenting himself. He discovered that yellow was brighter than white on canvas because it creates a greater illusion of brilliance, and that black can be made to appear darker by acutally adding red to it to produce a sense of depth. Considerations of contrast and chiaroscuro are important in his work; but the painting itself is merely the final stage of several processes.

In fact, most of his illustrations begin with an initial thumbnail sketch in pencil on a pad of tracing paper. He draws something, then puts this under another page, drawing over it and changing things so that the composition develops. He does this stage without the aid of models or any visual references until he's satisfied with the overall design and the movement of the figures in it.

"I always start with an image of some sort, but it's very abstract. I sit down and see what happens. Rather than specific figures I have a certain idea of masses in particular areas and a sense of negative space in other areas. I try to create a sense of motion and rhythm within the composition. Once I've got that I start working with the figures and decide what kind of process I want to use for what I'm trying to do." The thumbnail sketch is basically a kind of personal map. "You wouldn't be able to identify any particular detail."

Once the sketch is complete, he moves on to the photographic stage. "I used to work with professional models, but now I find I get a more spontaneous and natural feeling if I work with non-professional people. I use my wife, myself and also my friends. Some of them are artists themselves and they have a feeling for it. They move well and model well." Does he have to act like a film director in order to get the poses he wants? "No. I haven't even thought about the right way to direct people. It's very instinctive and depends on how the person feels. Mostly I just describe what's happening in the painting to the model rather than asking for a pose. I prefer it if they're not tied to the original sketch. It's more important for the model to feel natural."

He photographs them in both static and action poses, but in his paintings he likes to avoid exaggerated action because he doesn't want a comic-book effect. He is also at pains to avoid the photographic strangeness of frozen action, aiming for a more graceful, classical movement. In the past he worked in black-and-white with professional photographers, but now he prefers colour photographs. It gives me more variation, more values in the tones. I don't use coloured lighting or

Primeval Princess, 1978 Poster

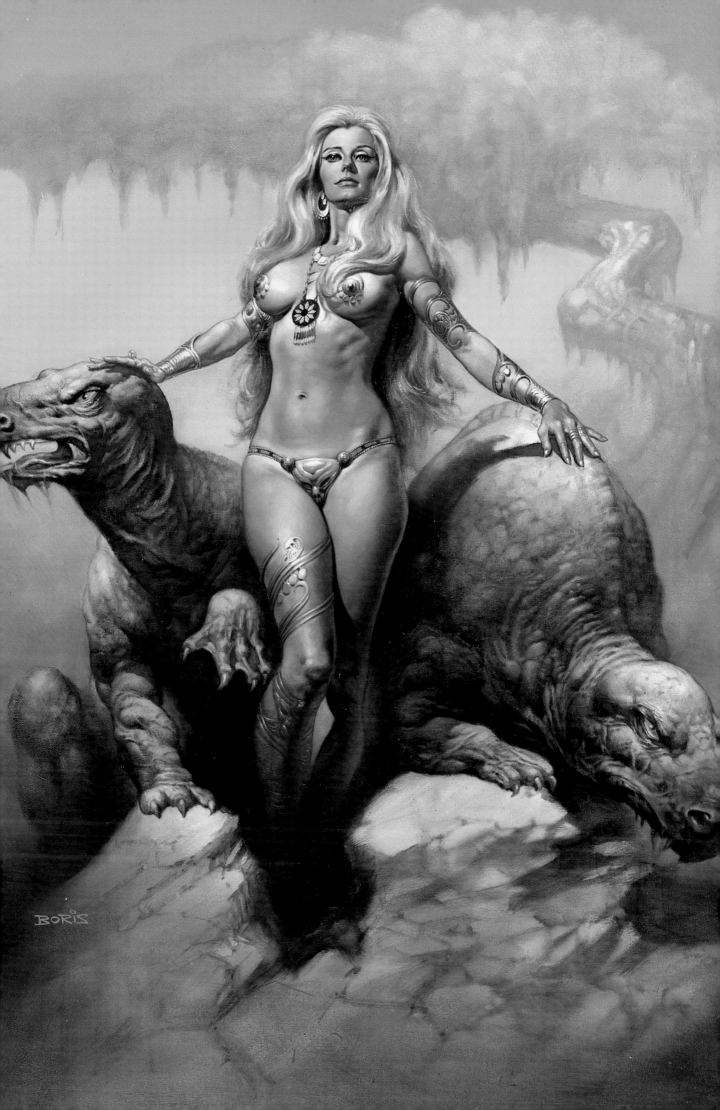

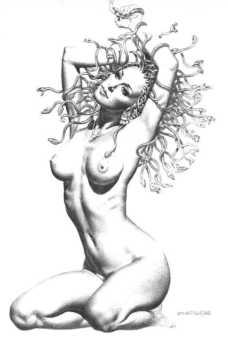

Pencil Drawing from Mirage

anything fancy, and I don't let the colour of the photograph influence me in the painting. I use my own colour schemes. The photographs are simply a reference, not something I want to copy exactly. They are easier and cheaper than having a model standing in front of me for hours on end."

Vallejo paints under fluorescent lighting, which he finds a good, unwavering simulation of natural light. He does an underpainting in an acrylic gesso, which seals the surface, then does the glazing and rendering in oil paints. He prefers to use acrylics rather than the traditional method of underpainting with warm colours in oils because it dries more quickly. "The painting itself takes anything from three to six days. I don't like to spend too much time on a particular composition, otherwise I get tired of it."

The finished product as it appears to the public is usually in the printed form of book covers or posters. Does he see the original paintings as lasting commodities like works of art? "I've changed my approach in many respects from five or six years ago. Formerly I used to feel that if a painting lasted as long as I did, that was fine. But now I feel that if I really put myself into a painting I would like it to last as long as possible." Because of this, he no longer uses a regular illustration board for painting since it contains acid and causes the painting to deteriorate within ten years. Now he works on a special illustration board using acid-free cotton, which is like a rag paper and as durable as any canvas.

Like many artists, Vallejo sees painting as an integral part of his life. "I never found it a struggle to paint or draw. It came very naturally. The struggle came later in trying to improve. What I'm painting now really

happened by accident. Though I decided at the age of eighteen that painting was going to be my career, fantasy art only came to me as a means of expression eight or ten years ago." It seems, nevertheless, to be his métier, allowing him the free expression of both the exotic and the erotic imagery which would not be easy to combine in other fields of illustrations.

Despite his experience and natural aptitude for art, Vallejo still suffers from what he calls "The fear of the empty canvas" — a concern that he may not be able to fulfill his ambitions coupled with a simple boredom with all the preliminary stages that must be undertaken before he can actually begin painting. But the painting itself is a joy, something he would do even if he did not make a living out of it. He gets a great satisfaction out of experiencing the composition taking shape under his hands.

For Vallejo painting is instinctive, and his only conscious aim is to create some sort of visual impact whose interpretation is to be left to the viewer. When considering the effectiveness of one of his paintings, he is most concerned with the figure in it, which he hopes will captivate the onlooker so that excessive background detail is not important. There is no particular message in his illustrations which he consciously puts there; though he is aware that the symbols and images which he uses have their own significance, he simply concentrates on presenting the vision conjured from his imagination.

The final painting, however, contains perhaps only half of the original concept which he had in his mind at the outset; the act of drawing and painting transforms the initial inspiration. Ideas for illustrations will sometimes come to him when he's half-asleep, though very few are the full-blooded products of dreams. He feels strongly that the imagination must be cultivated and developed in parallel with an artist's technical skills; just as technique improves with practice, so the imagination can be trained to respond to stimuli in the ordinary world such as an interesting sky or the face of an attractive woman passing in the street.

Apprentice artists come to him for advice and criticism on their work. He believes that many of them make the mistake of wanting to do professional artwork such as book jackets or movie posters before they've even learned to draw properly. Or they'll watch him at work, paying closest attention to what particular colours he's using instead of analysing

The Red Amazon, 1981 Book Jacket

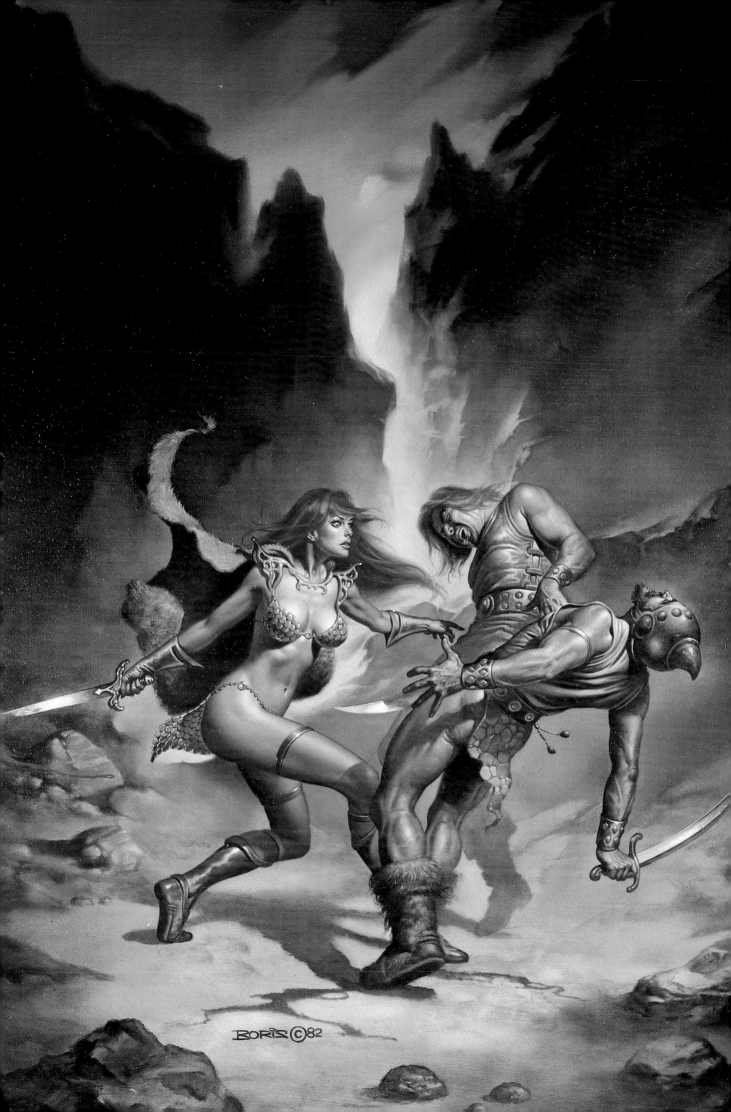

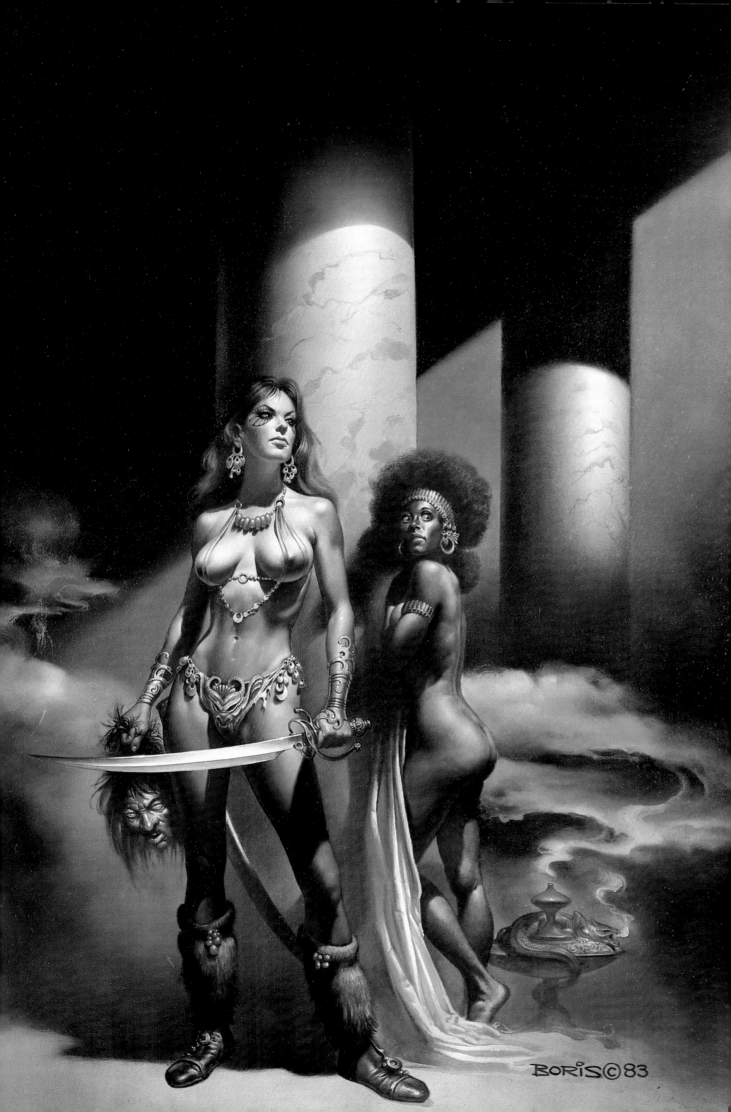

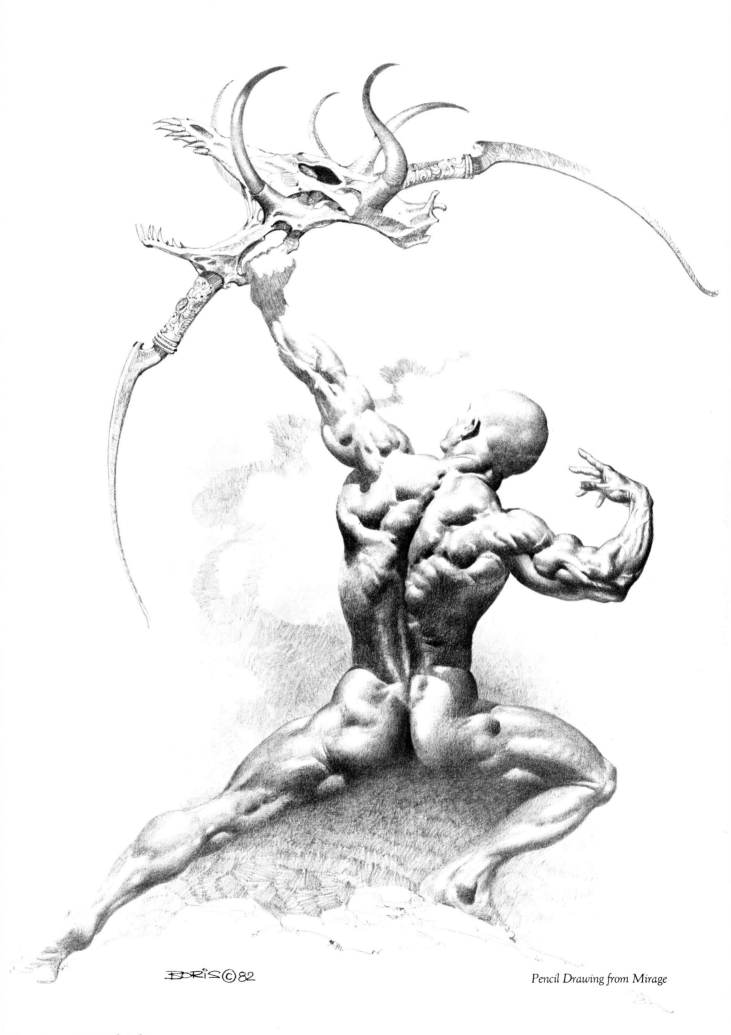

BORIS ©82

Pencil Drawing from Mirage

e Executioner, 1983 Book Jacket

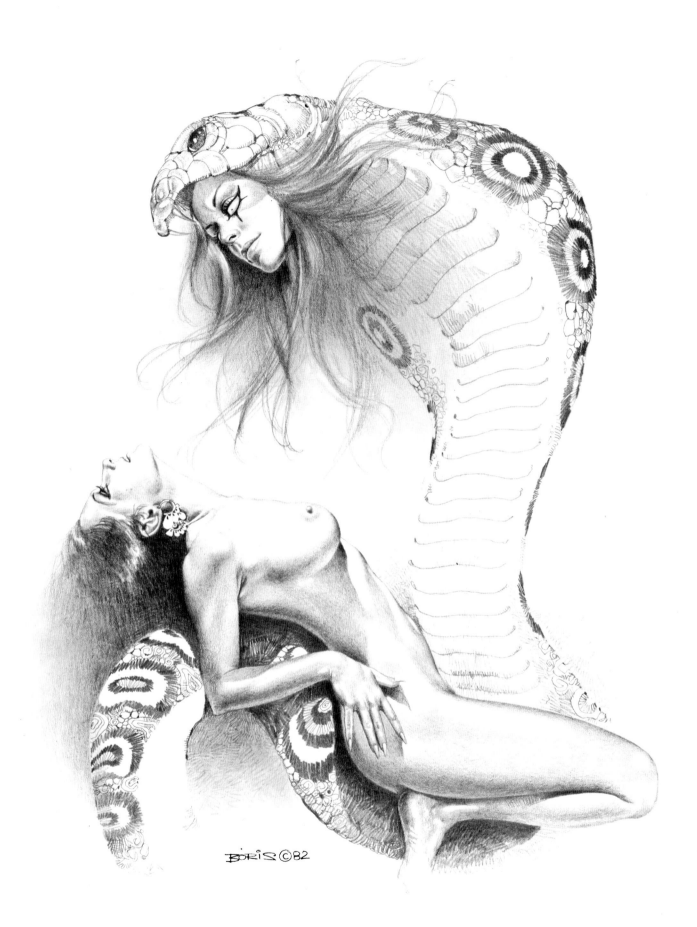

BORIS ©82

Pencil Drawing from Mirage

what is actually happening in the painting and trying to understand how the particular colours relate to the effects he's trying to achieve. He's often asked what colours he uses for skin tones, to which there is no simple answer since the colours used will depend on the particular composition. The essence of developing further once you are secure in the basics of art is to confront your own problems and find your own solutions to them rather than trying to copy the work of more experienced hands.

This concern with a proper apprenticeship underlies his whole approach to art. A good grounding in the basics of the craft also makes it possible to break established rules effectively by using colours in unexpected ways. Such experimentation always carries the risk of failure, but for Vallejo it is essential that an artist try new things if he is to stand out as an individual. Failures and successes alike must be regarded in the wider perspective of nurturing one's talents.

Vallejo enjoys the work of other painters, and he buys art books by the score Apart from his obvious talents, his continuing success is doubtless connected with an avoidance of complacency. He remains self-critical and is continually seeking fresh challenges. It's the tantalizing gap between aspiration and achievement which provides the impetus that keeps him striving towards better and better things.

Vallejo himself is very conscious that he's still developing as an illustrator, but he uses this awareness as a springboard for his own ambitions rather than letting it daunt him. He's kept very busy with commissioned art for book jackets, movie posters and advertising material, but he only sells printing rights in the illustrations and the originals are always returned to him. For book-cover art he is usually sent the manuscript of a novel. "I'd love to say that I read all the manuscripts I get, but often there isn't the time so I'll glance through the pages and try to convey the atmosphere of the book." He's also learned to live with the frustrations of having cover-art returned to him with brass brassieres or G-strings added to cover up the more delicate parts of his female anatomies. Even so, he's found a purer expression for his imagination in illustrated books such as *Mirage*, which allow him more freedom to explore the eroticism often implicit in his art. He's presently working on a new book with his wife, who was herself a successful illustrator before turning to writing.

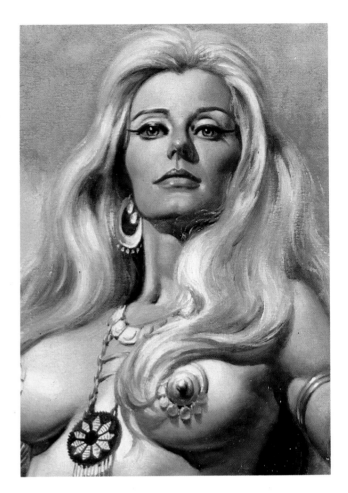

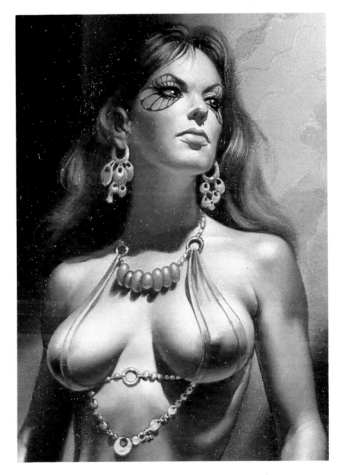

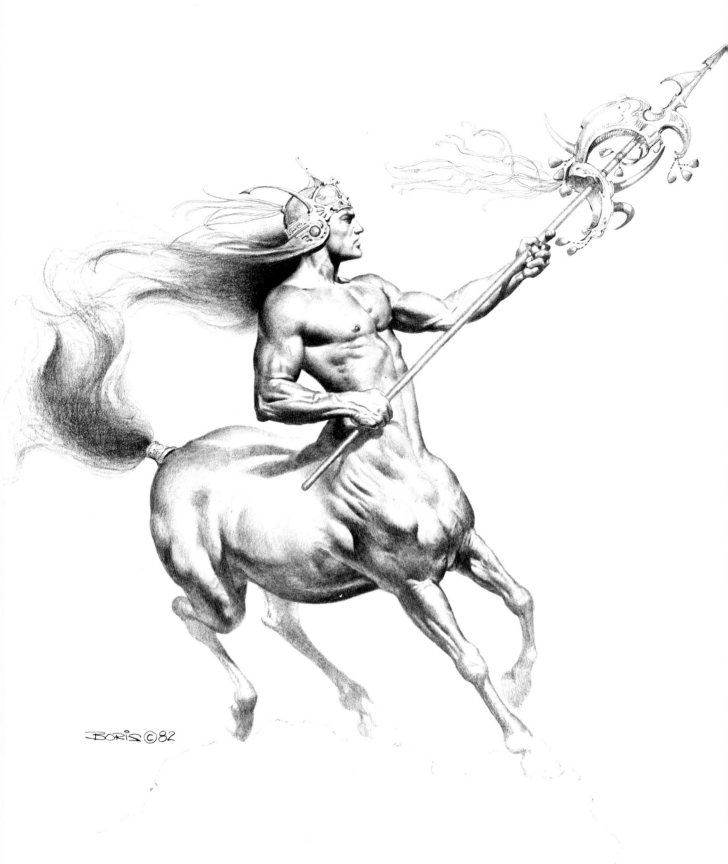

Pencil Drawing from Mirage

Invictus, 1982 Book Jacket

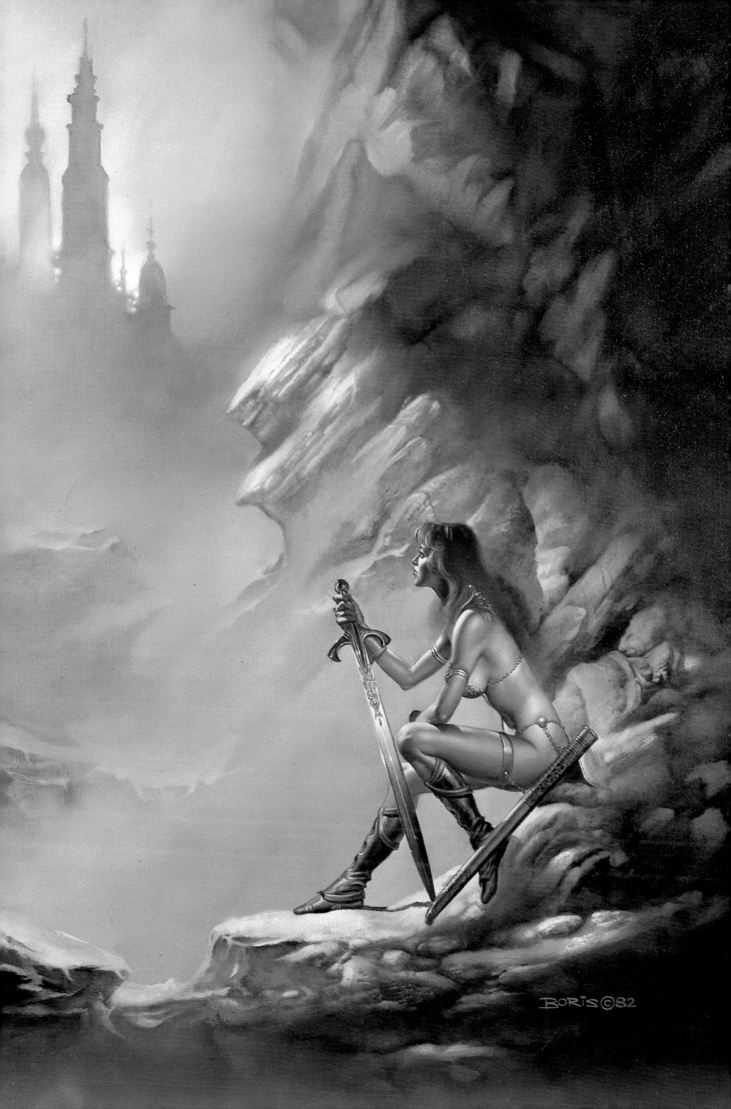

Afterword

One definition of art is the taking of ordinary things and the combining of them in extraordinary ways. It's often said that there's nothing new under the sun and that originality is the capacity to synthesize what already exists into novel forms. The foregoing interviews seem to bear this out. Fantasy art deals in the unusual or bizarre, but no matter how fresh an image seems to be, it invariably originates from some past or present experience — a memory, a photograph, an object. The fighter aircraft is transformed into a starship, a girl on the street becomes an Amazon warrior, an ordinary kitchen item is turned into a futuristic weapon.

Fantasy art is as much a product of its age and about its age as anything else. Other worlds are beyond our reach, and the real future cannot be seen. We are all products of our particular time, and we cannot escape its conventions, prejudices and unconscious influences. The fantasy artist strives for a sense of otherness from what we know exists, yet everything he does arises from the here-and-now. He may beguile us into thinking that we've been transported to the ammonia ice-deserts of another planet or the blood and steel of some barbarian realm, but secretly he's expressing something about the time in which he lives.

When asked the crucial question: "Where did you get the idea?" most of the artists talk of obvious reference materials or say that the idea just seems to come to them, almost as if from an external source. They may even see themselves as vessels through which an idea expresses itself rather than being the actual creators of it. But once the germ of an idea arrives, most of them do sketches and doodles which develop it until it's ready for full execution.

What exactly is happening here? That ideas are somehow plucked out of nowhere by the artist is a notion as romantic as it is implausible. It's more likely that ideas arise in the unconscious mind — perhaps in that part of the brain which is reputed to deal with visual imagery, colour, music and daydreaming as opposed to the more concrete side which handles such activities as language, logic and manual skills such

as writing and painting. This is only speculation, but if it's true it would explain why artists don't really give an intellectual explanation of where their ideas come from because they come from the non-rational part of the brain. By doodling and sketching, the artist then makes the link, between the mind's eye and the hand, allowing the idea to emerge.

This is, perhaps, a mechanistic view of how the imagination works, but it's only a general description of a process and may prove to be inaccurate. Ultimately we cannot penetrate the mystery of the individual act of creation because no one really knows how ideas take shape in the mind. And what emerges more forcibly than anything else in this book is that all artists are different from one another. The way in which they achieve their effects can't be duplicated by anyone else, except as a pale imitation.

Nevertheless, common factors can be seen in these interviews, and two in particular are worth stressing. The first is that most artists are collectors of things — be it physical reference materials or simply memories and impressions. Artists tend to have vivid recollections of their childhoods; they remember looking at things and drawing and painting from an early age. Youthful experiences shape the adult imagination, and the potential artist is characterized by his intense perceptions and his urge to reflect these visually.

Just as important, however, is the diligence and dedication which is then applied to perfecting a style and technique. Most artists serve a long and poorly paid apprenticeship, but without this apprenticeship it's impossible to produce mature work. A formal education in art is not necessary, but dogged practice is, otherwise the artist will never develop the craft to display his talents at their best.

In these respects all eight artists tell a similar story, but otherwise they differ. There is no one type of natural artist; he can be forged under a variety of influences. It is interesting, though, that half the British illustrators included here cite the "Dan Dare" comic strip as

having made a big impression on them; and all were stimulated by the kind of art which conveys a sense of wonder. They also have a tendency to be fascinated by natural history subjects — in other words, by plants and animals and environments in their wild state. Again this suggests young minds which are acutely receptive to visual impressions and inquisitive of the natural world around them.

The modern freelance artist is also a product of his age in practical ways. He frequently works under commercial pressures, and these affect his choice of materials. Movie-work in particular, with its demand for speedy visualizations, may prompt an artist to switch from traditional oil paints to faster drying acrylics; and auxiliary materials such as transparent film or masking fluid which were not available in previous centuries have also become important. Above all, though, the advent of offset litho printing has allowed illustrations and paintings to be reproduced relatively cheaply as book covers, posters or magazine illustrations. What an audience now sees of an artist's work is usually in printed form, and most artists bear this consideration in mind, tailoring their technique accordingly.

The romantic image of the artist as someone who enjoys solitude and relishes the mystique of his craft is one that most of the artists here positively reject. They take a matter-of-fact approach to their work, and they often speak of the enjoyment and stimulus which they've obtained from working in teams and under commercial constraints; far from being frustrating, commissioned work often forces them to extend themselves and develop their art in unexpected ways. Having a good agent also seems valuable, if only in terms of economic survival in a competitive world.

Whether self-taught or art-school educated, the eight very different artists in this book have one thing in common: their art has a literal, mannerist style in the sense that it portrays idealized images which express the essence of an object or a scene with a super-realism that's at odds with the conventions of establishment art. In their imagery,

too, they also reject current forms. Most of the buildings and artifacts of this century have been dominated by a bare rectilinear functionalism, but the images in today's fantasy art harken back to organic forms and to colourful materials. It has a human element in which visual richness has its place, figures and backgrounds are vivid, while buildings and vehicles are adorned with decorations or bristling with intricate detail.

This is surely a reaction to the minimalist style of the 20th century in which concrete blocks and sheets of glass, metal and plastic exert their influence on the design of everything from skyscrapers to pocket calculators. If the real future becomes more ornate and colourful, it will be today's fantasy artists who heralded the change.

One final point on the art itself: it tends to have a narrative quality, and its images often possess an innocence and freshness even when their immediate impact is unequivocal. More than any other art, it represents the outpouring of the unconscious with a minimum of intellectual trappings, and it's significant that most of the artists in this book make a point of not questioning the rationale behind their illustrations or positively deny that it has one. Spontaneity and the unfettered impulse seem to be essential to allow the fantasy vision to emerg most powerfully, replete with primal imagery. Its subject matter is frequently apocalyptic, and perhaps it reflects the unease we presently feel as we approach the 21st century under the shadow of nuclear warfare: it presents modern versions of Heaven and Hell which can reflect our brightest hopes or confirm our darkest fears.

It there's one lesson to be drawn from this book it's that every artist of any consequence finds his own means of expression, using imagery which is personal to him and techniques which he has developed by dint of practice and sheer hard work. Private obsessions coupled with raw talent and a determination to master the technicalities of the craft are what make for a successful artist; they are also what make him in the end unique.